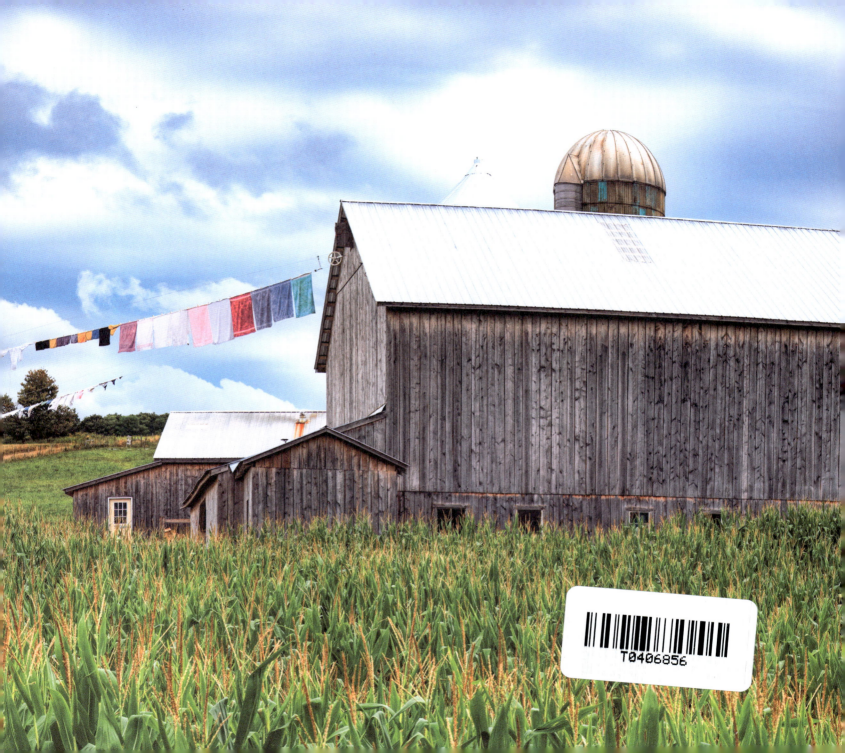

DAVID SKERNICK

BACK ROADS *of the Mid-Atlantic States*

PENNSYLVANIA, NEW YORK, NEW JERSEY, DELAWARE, MARYLAND, AND VIRGINIA

SCHIFFER PUBLISHING

4880 Lower Valley Road • Atglen, PA 19310

Other Schiffer Books by the Author:

Back Roads of Northern California,
ISBN 978-0-7643-5762-6

Back Roads of Southern California,
ISBN 978-0-7643-5763-3

Back Roads of the Southwest,
ISBN 978-0-7643-5858-6

Back Roads of the Great Plains,
ISBN 978-0-7643-6186-9

Back Roads of the Pacific Northwest,
ISBN 978-0-7643-6290-3

Back Roads of the Midwest,
ISBN 978-0-7643-6483-9

How Did You Get That Shot?,
ISBN 978-0-7643-5728-2

Easy Astrophotography,
ISBN 978-0-7643-6684-0

Copyright © 2025 by David Skernick

Library of Congress Control Number: 2024943733

All rights reserved. No part of this work may be reproduced or used in any form or by any means—graphic, electronic, or mechanical, including photocopying or information storage and retrieval systems—without written permission from the publisher.

The scanning, uploading, and distribution of this book or any part thereof via the Internet or any other means without the permission of the publisher is illegal and punishable by law. Please purchase only authorized editions and do not participate in or encourage the electronic piracy of copyrighted materials.

"Schiffer," "Schiffer Publishing, Ltd.," and the pen and inkwell logo are registered trademarks of Schiffer Publishing, Ltd.

Edited by Ian Robertson
Type set in Proxima Nova

ISBN: 978-0-7643-6928-5
ePub: 978-1-5073-0552-2
Printed in China

Published by Schiffer Publishing, Ltd.
4880 Lower Valley Road
Atglen, PA 19310
Phone: (610) 593-1777; Fax: (610) 593-2002
Email: info@schifferbooks.com
Web: www.schifferbooks.com

For our complete selection of fine books on this and related subjects, please visit our website at www.schifferbooks.com. You may also write for a free catalog.

Schiffer Publishing's titles are available at special discounts for bulk purchases for sales promotions or premiums. Special editions, including personalized covers, corporate imprints, and excerpts, can be created in large quantities for special needs. For more information, contact the publisher.

Heaven and earth never agreed better
to frame a place for man's habitation.

—John Smith

Over the years, I have had many private photography students. Most were adults. Years and years ago two students started with me as kids. Shelby was twelve, Scottie was eight, and I was in my twenties. I spent long hours with each of them in the darkroom and out photographing, talking about our dreams. I would tell them how all I wanted was to drive around the country taking pictures. Forty years or so later, Shelby is a college professor and Scotty is a psychiatrist. They have each raised amazing children of their own and have incredible lives enriching others. I spend my time driving around the country taking pictures. I believe that we three followed our dreams in part because of the confidence we shared in each other. I am dedicating this book to my young friends who are no longer that young, although we all feel like we are. I am so fortunate to still have you in my life.

INTRODUCTION

When most people think about the Mid-Atlantic states, they think of New York City, Philadelphia, Baltimore, and other big sprawling cities. Travel with me and you will find yourself on the hidden highways that lead to places like Shushan, New York; Cherry Ridge, Pennsylvania; and Fizzleburg, Maryland. We will stop for Kohr Soft Ice Cream in Tuckerton, New Jersey, pick up some local honey and cider in Woodville, Virginia, and maybe have some pie at the Lyndon Diner in York or Lancaster, Pennsylvania. Not the kind of eating and shopping you might have expected, but I think you will enjoy this trip. You might even love it as much as I did.

This is a very old part of the country, rich in history. You see it in the architecture, you hear it in the people you stop and talk with, you feel it in the trees, and I hope you will sense it in my photos. My goal is always to have you feel what I felt and see what I saw. The Mid-Atlantic states are living American history. I tried to give you the old, the new and, of course, the beautiful natural areas that have not changed and hopefully never will. Places like the Adirondacks in New York, Assateague Island National Seashore in Maryland, Prime Hook National Wildlife Refuge in Delaware, and the Blue Ridge and Shenandoah National Parks in Virginia. There is beauty all over this area. Lakes, mountains, and rivers are everywhere.

My books are not meant to be exhaustive collections of photographs from each region. They are more a collection of places and things I see as I drive along. I travel 50,000 miles or so every year along the back roads of the United States. Cities and freeways hold little interest for me. I call this getting lost on "gray roads."

As I crisscross the back roads of this amazing country, I find little gems and prizes everywhere. If you are looking for your favorite spot or road, I may not have found it yet. I will keep looking and you are, of course, welcome to contact me and make suggestions. I would love to hear from you. Lots of my favorite places were found when I asked someone at a gas station or restaurant, "What's good to see around here?"

Most of my photographs reveal another kind of freedom: panoramic photographs. As a photographer, I was trained in the art of seeing things through the confined dimensions of a 35mm piece of film, approximately 3:2, slightly wider than tall.

Introduction

As all photographers have done, I have worked within these boundaries using wide angle lenses to capture more of the scene than would otherwise be possible, but the resulting distortion of distance and perspective never felt quite right. I found myself secretly jealous of painters, who could select any size canvas on which to create art. When I found panoramic photography, I realized I had discovered my unrestrained canvas. Panorama photographs are carefully crafted from multiple photographs that are combined to form one large image. With panoramas, I can photograph without traditional framing limitations. This is immensely satisfying for me, as I feel panoramas are best able to convey what you would have seen had you been standing there beside me when I took the picture.

Let's start off in Pennsylvania and drive north into New York, then south into New Jersey. After that we will explore Delaware and Maryland, then finish up in Virginia. It is a long ride—pack some snacks and a jacket along with your camera gear.

Bob 4 on New York Highway 30, Adirondacks

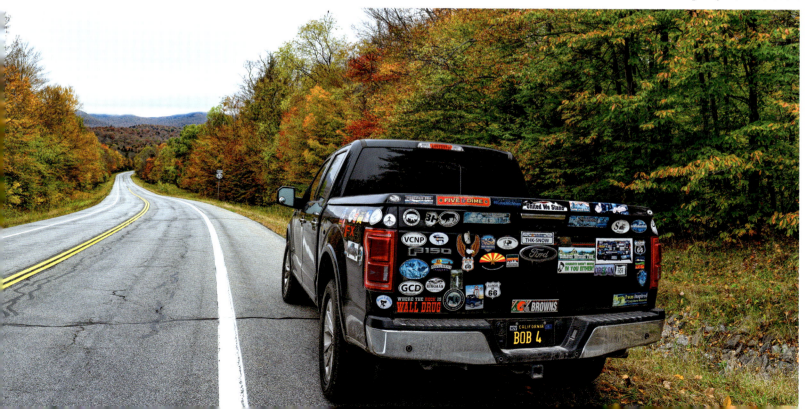

Back Roads of the Mid-Atlantic States

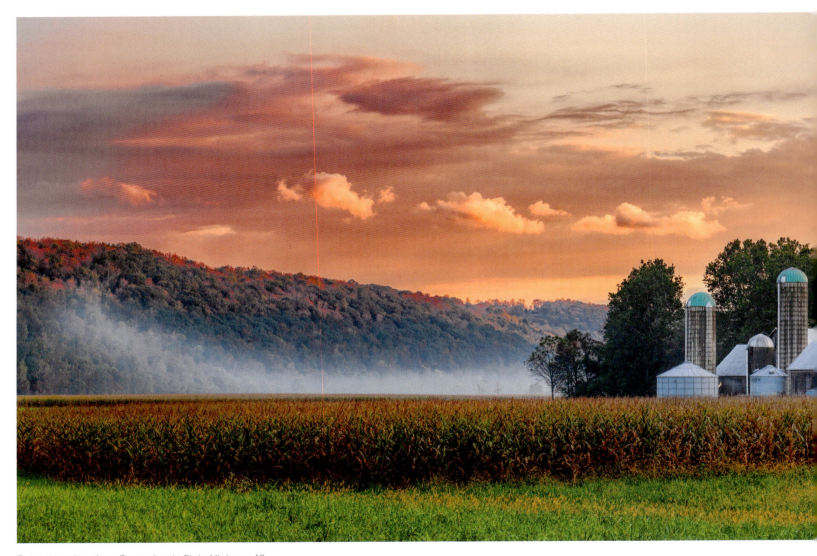
Farm at sunrise along Pennsylvania State Highway 42

Pennsylvania

Back Roads of the Mid-Atlantic States

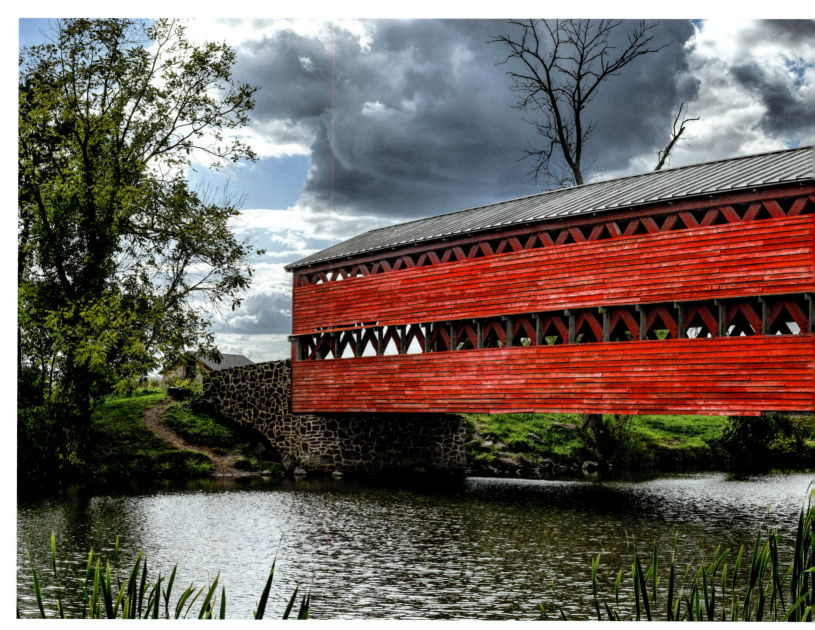

Sach's Bridge, Gettysburg, Pennsylvania

Pennsylvania

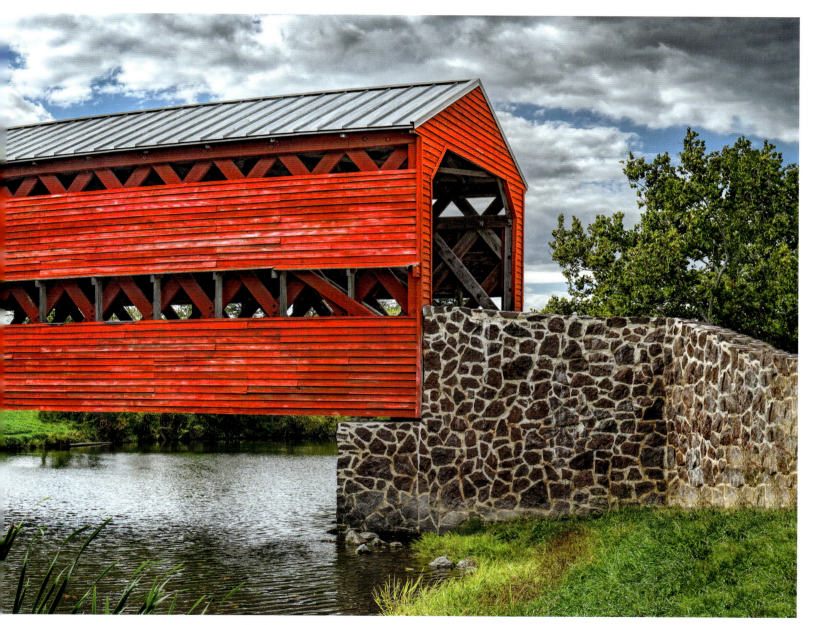

Said to be haunted, this bridge, built in 1854, was crossed by both Union and Confederate soldiers during the Civil War.

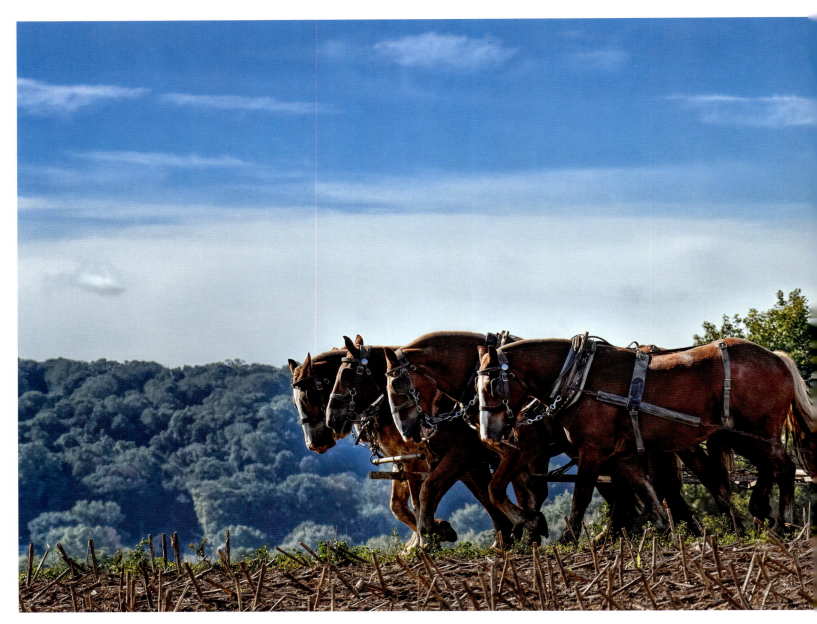

Paradise, Pennsylvania

Pennsylvania

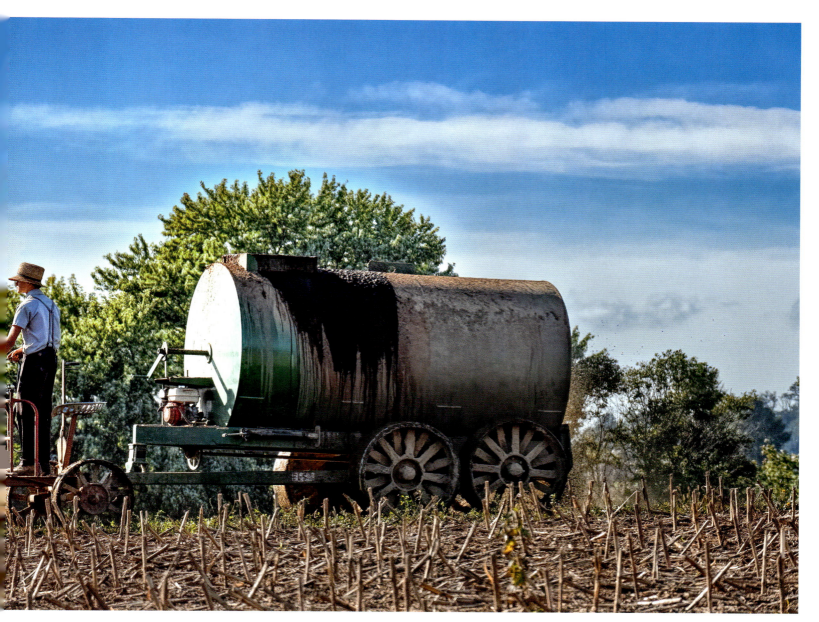

The Pennsylvania Dutch believe that having their picture taken is a sign of vanity.
I did my best to show a way of life rather than a recognizable person.

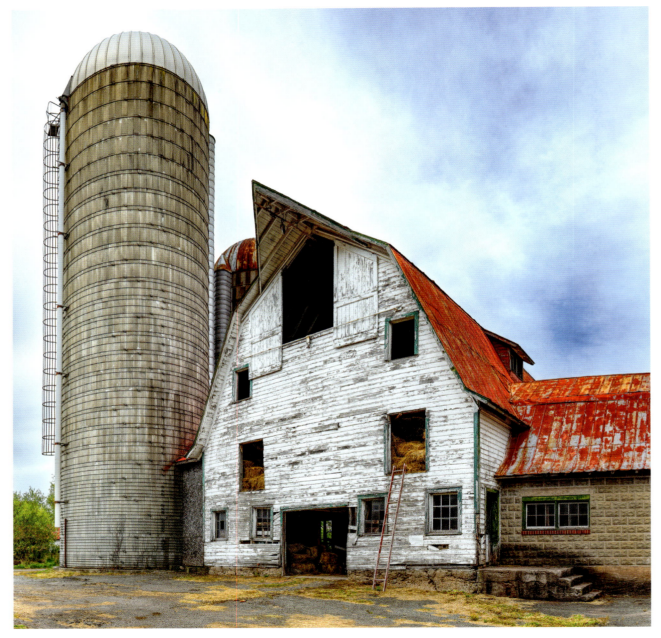

Clearfield Farms, Cherry Ridge, Pennsylvania

Pennsylvania

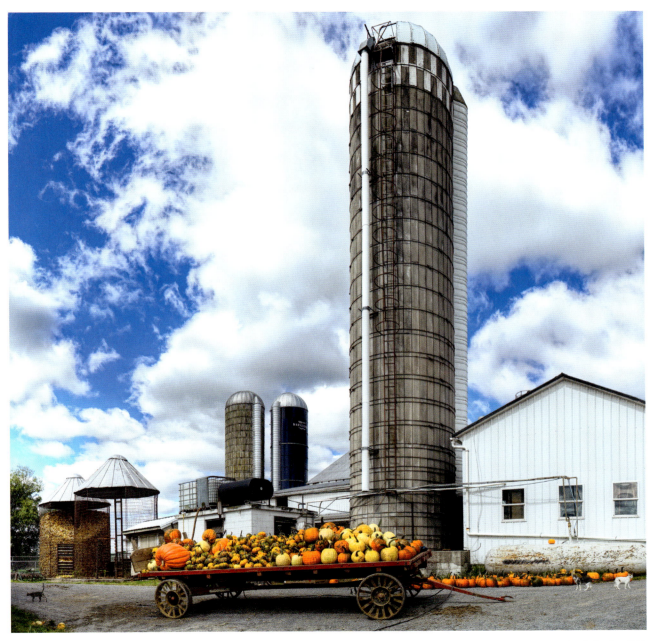

Chris's Farm, Leola, Pennsylvania

Look for the cats.

Back Roads of the Mid-Atlantic States

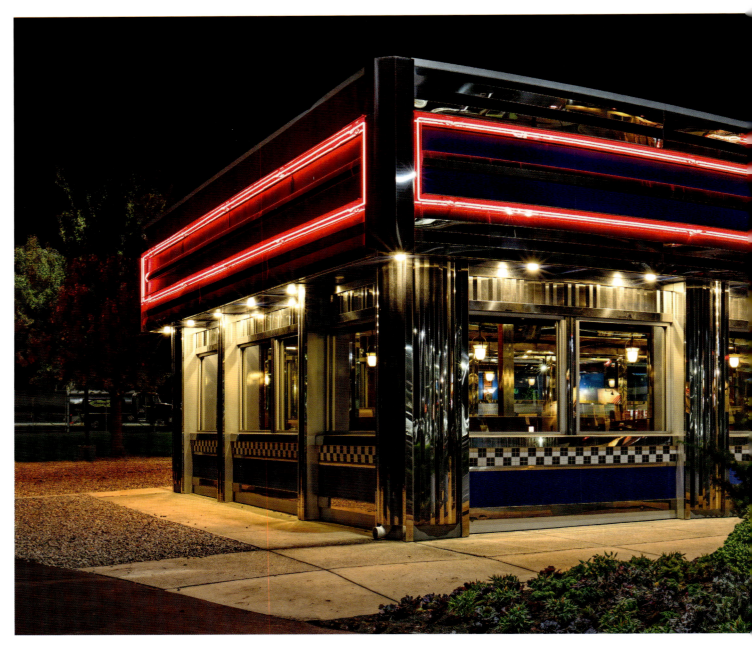

Lyndon Diner, Lancaster, Pennsylvania

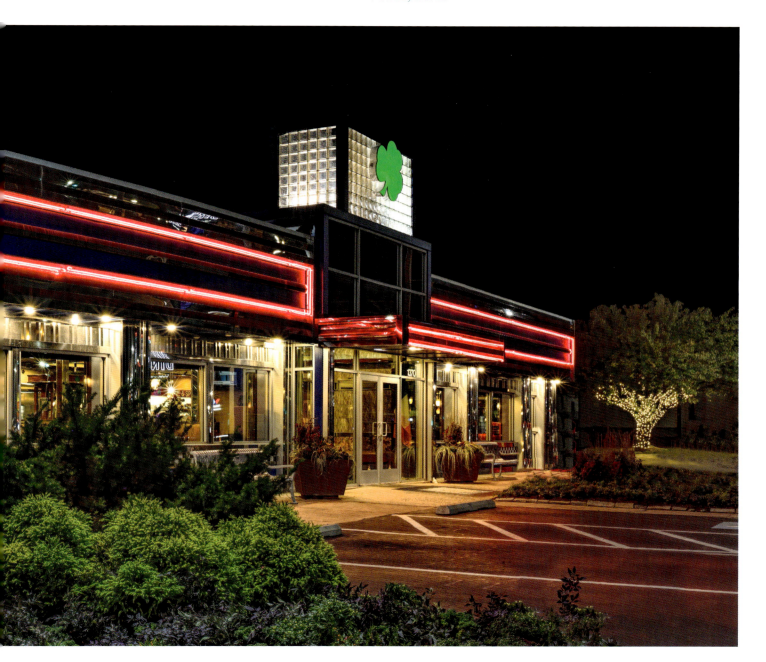

Back Roads of the Mid-Atlantic States

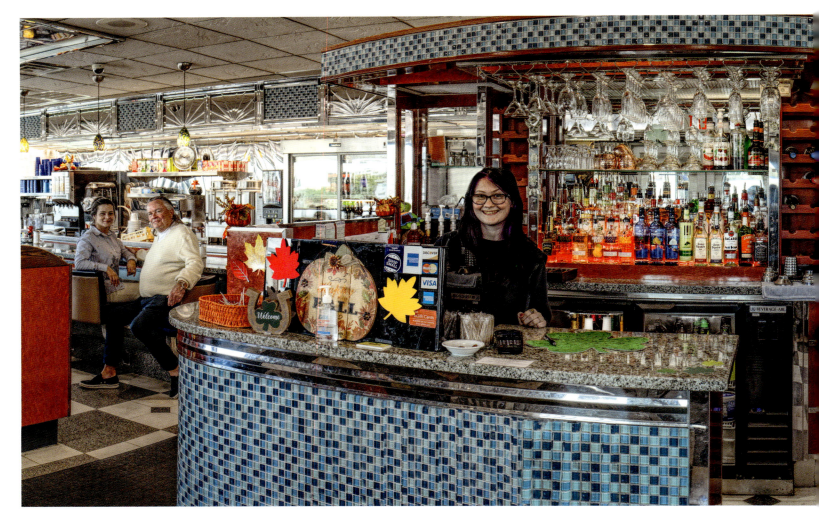

Lyndon Diner, York, Pennsylvania

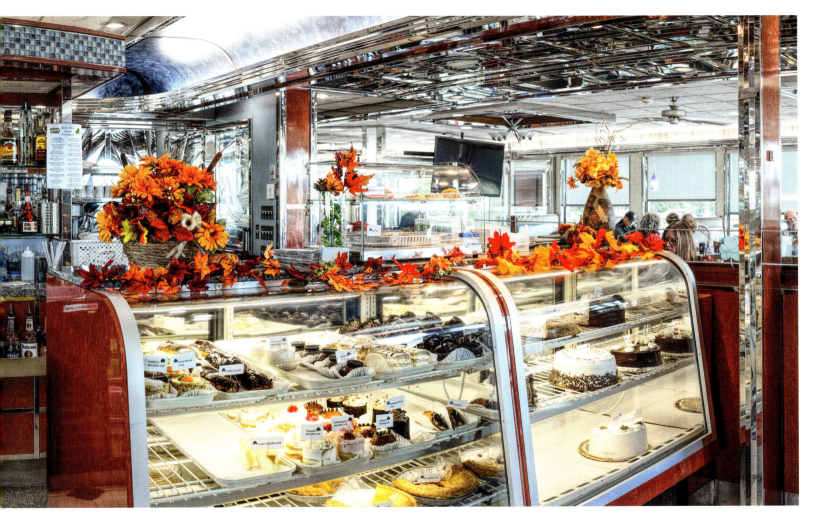

Thank you, Symira (*standing at the register*) and Lyndon (*pictured to the far left*) for allowing me to photograph this and your diner on the previous page. You were right, that pie is even better than it looks!

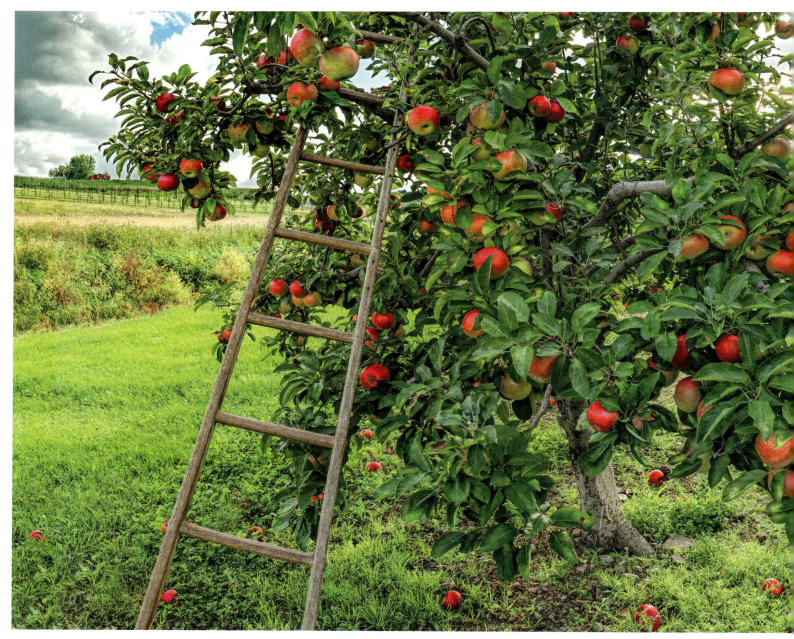

Apple orchard, Pennsylvania

Pennsylvania

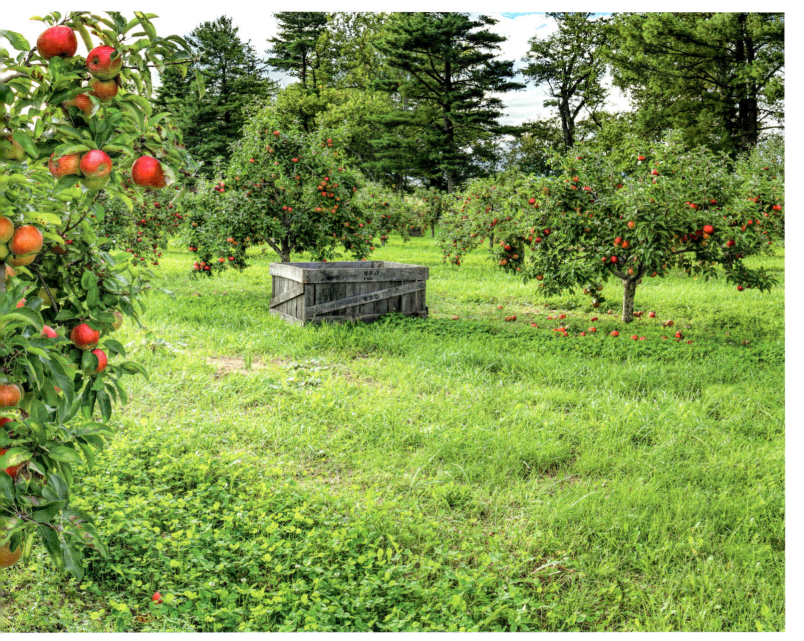

Yup, they were tasty!

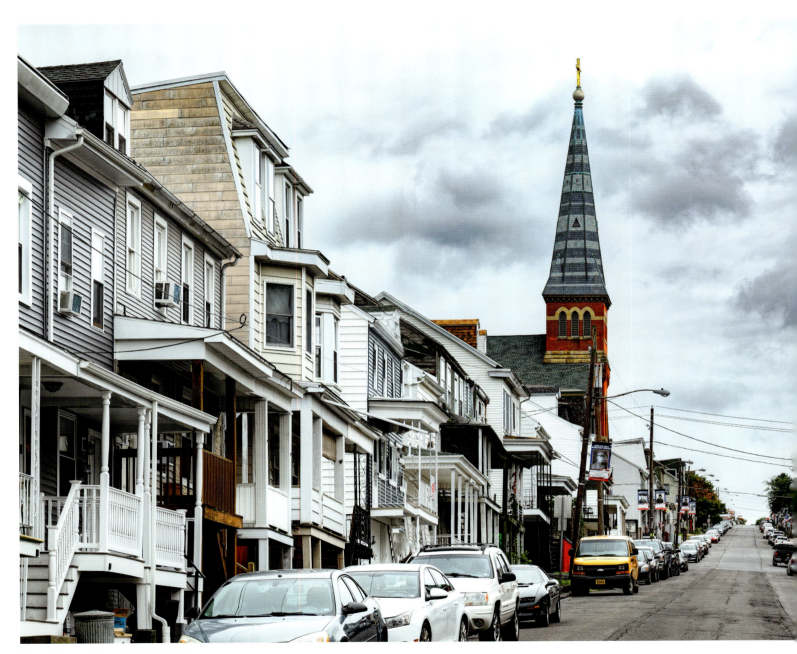

Walnut Street, Ashland, Pennsylvania

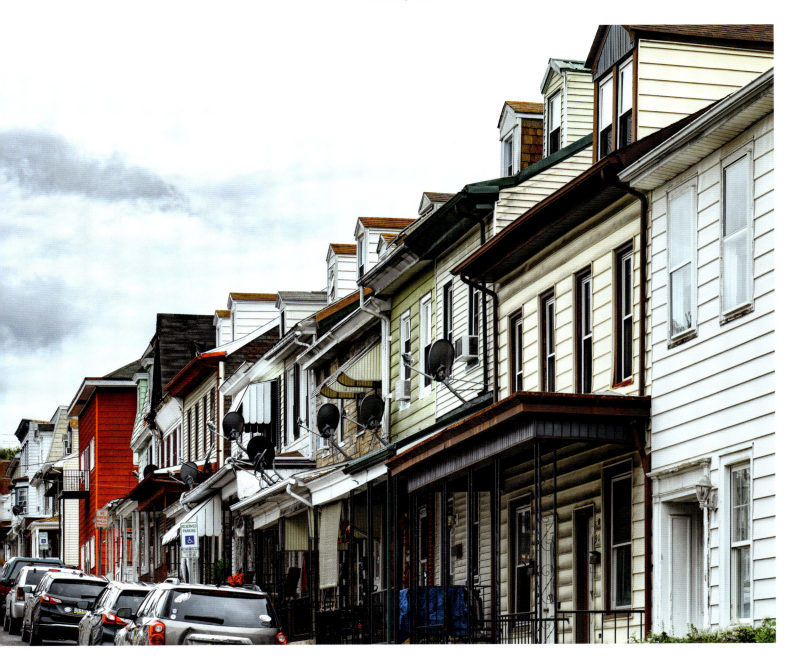

Back Roads of the Mid-Atlantic States

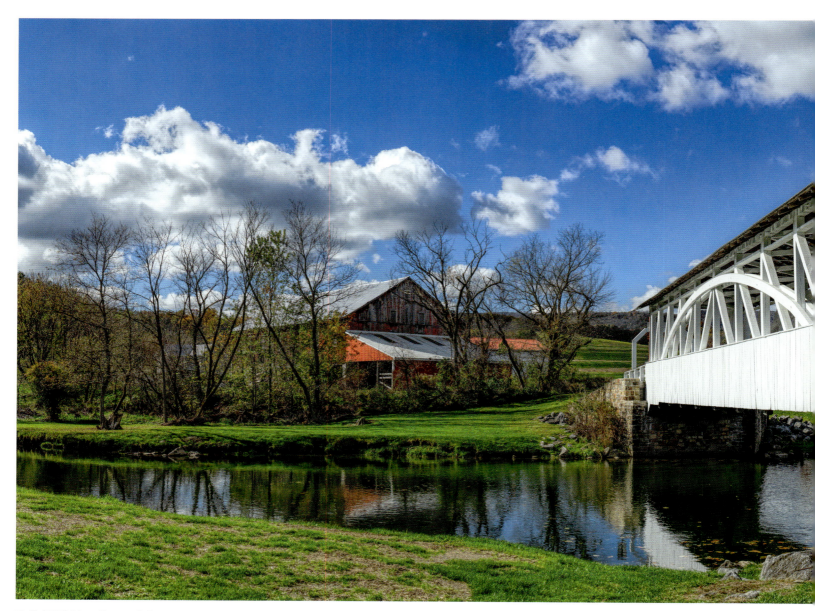

Hall's Mill Bridge, Hopewell, Pennsylvania

Pennsylvania

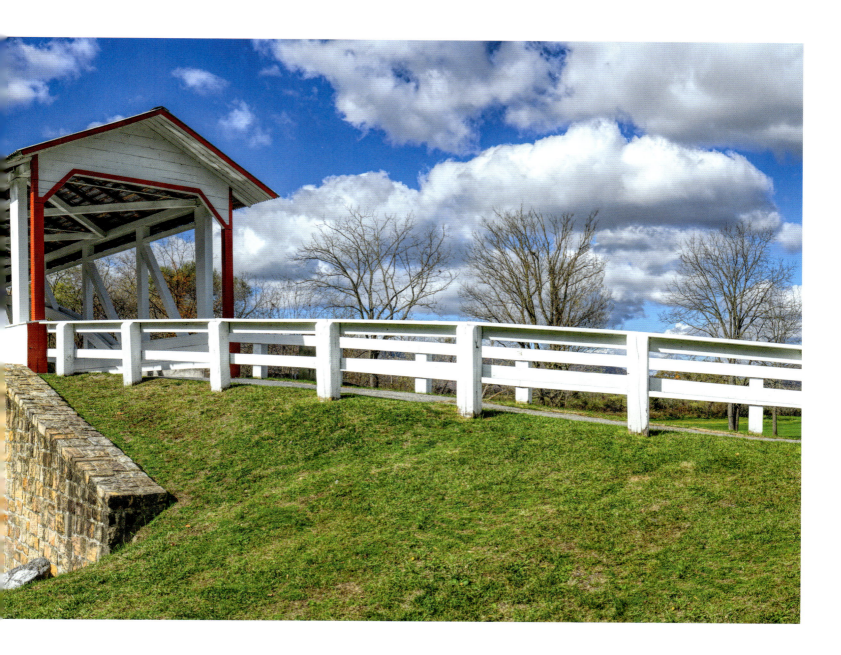

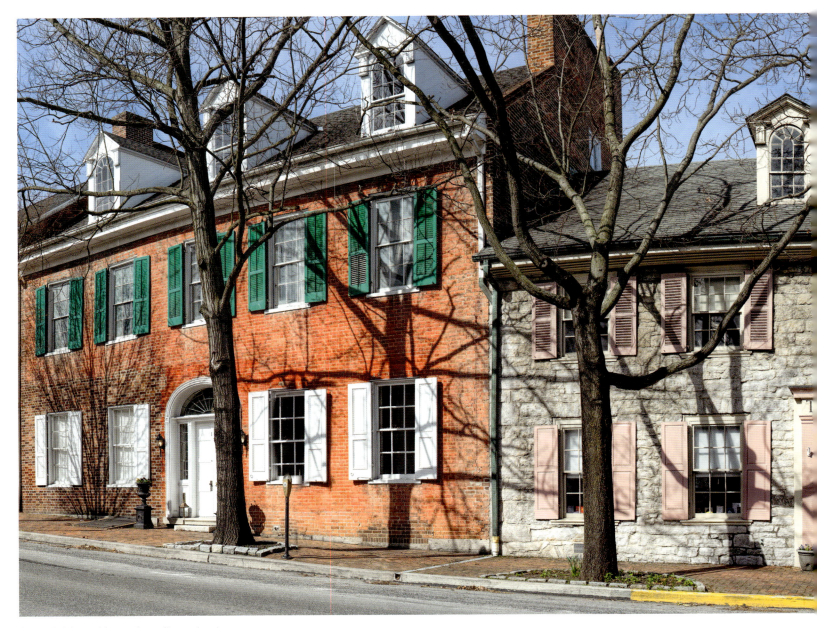

Fendrick Library, Mercersburg, Pennsylvania

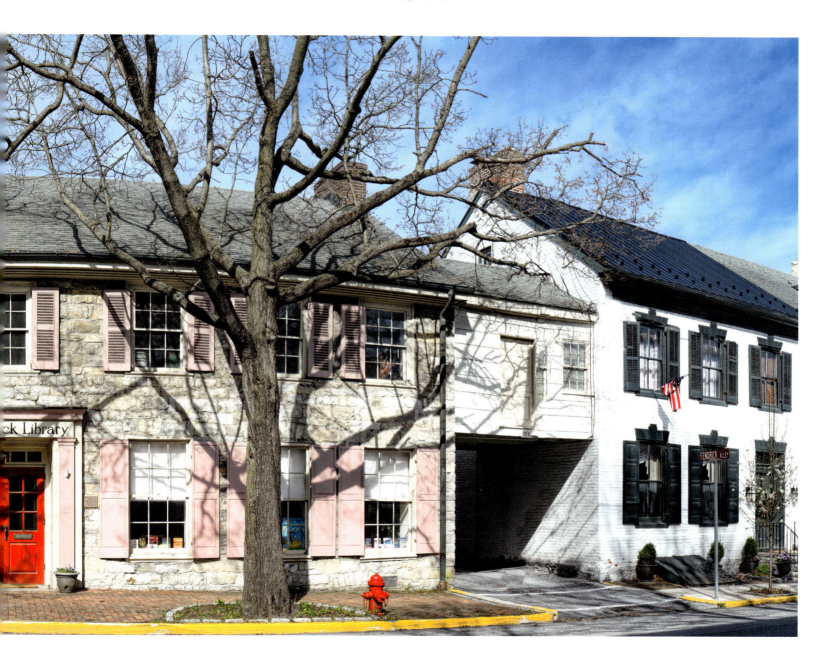

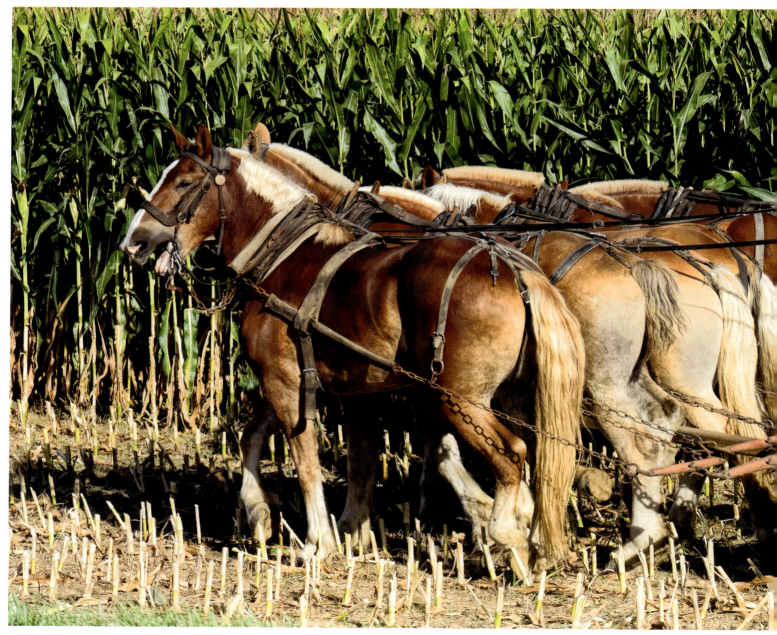

Lancaster County, Pennsylvania

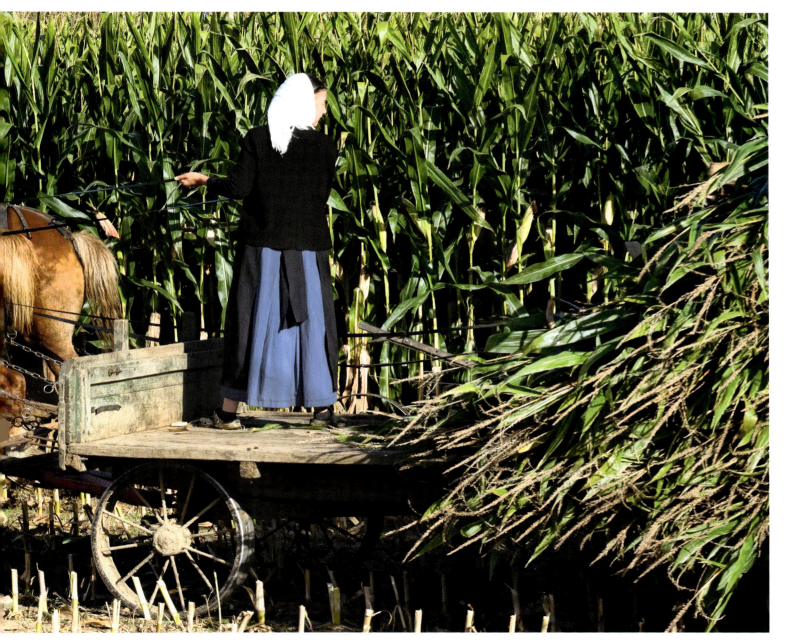

Farming without the help of modern technologies is a way of life for the Pennsylvania Dutch.

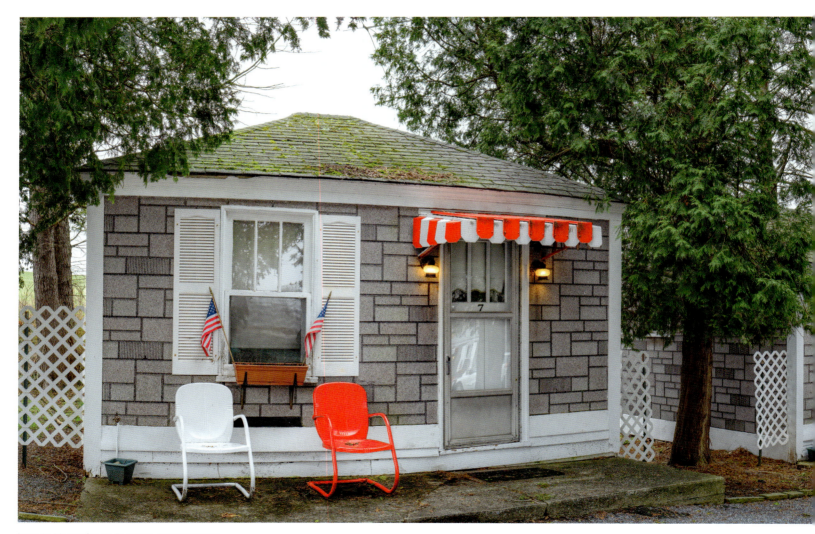

Lincoln Motor Court, Bedford, Pennsylvania

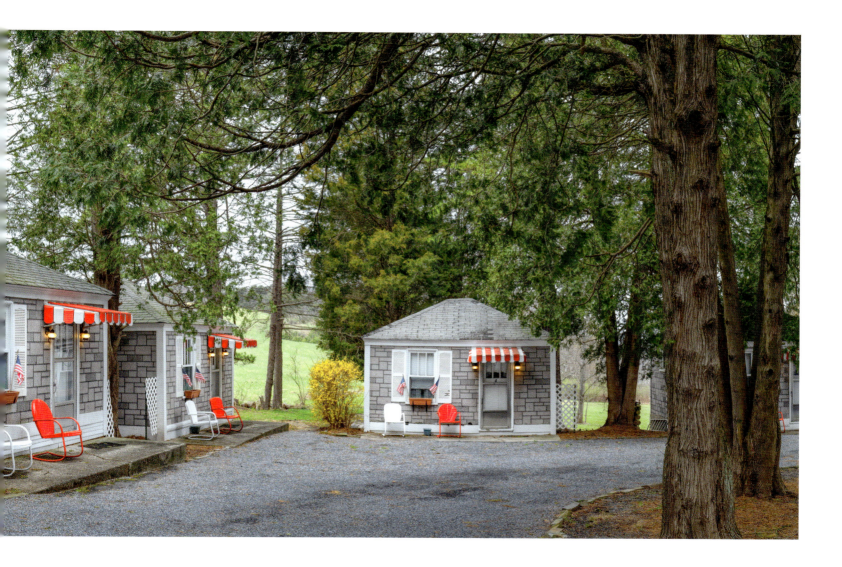

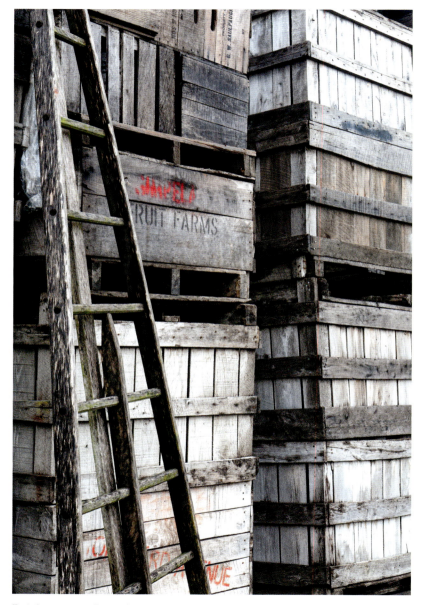

Fruit farm crates, Pennsylvania

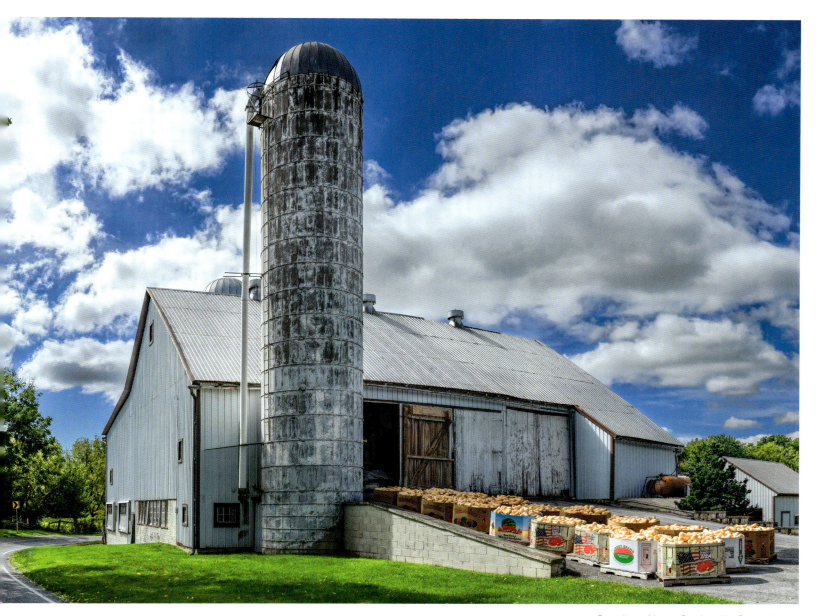

Gourds and barn, Gordonville, Pennsylvania

Back Roads of the Mid-Atlantic States

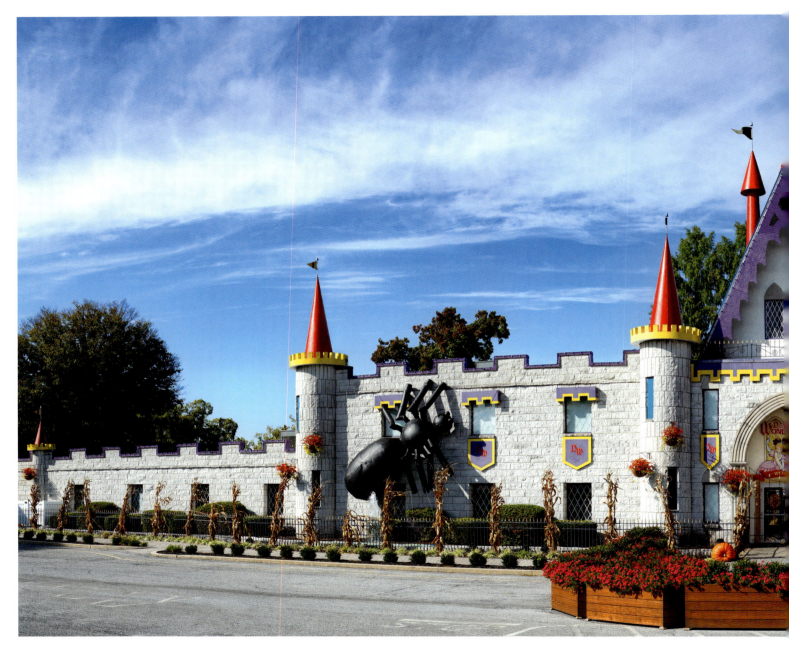

Dutch Wonderland, Lancaster, Pennsylvania

Pennsylvania

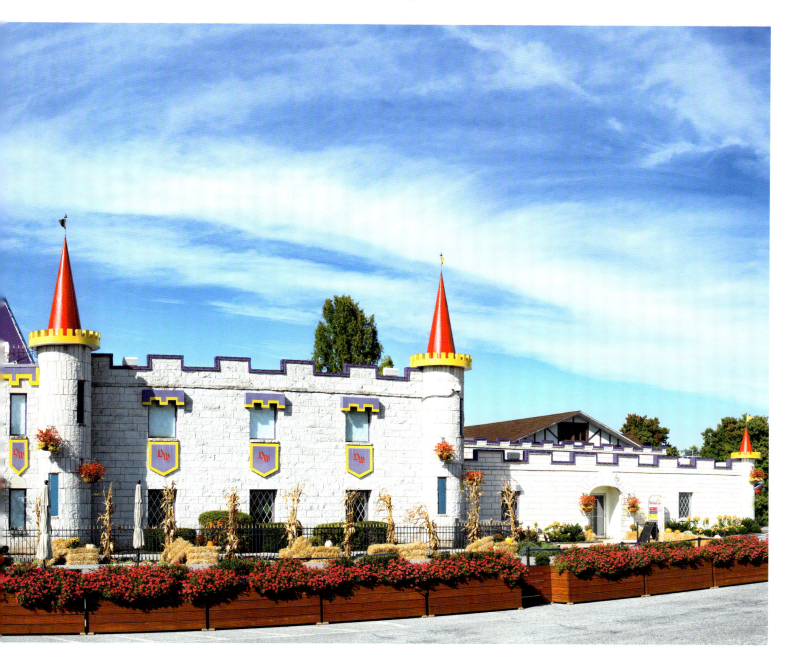

Fisher's Produce, Paradise, Pennsylvania

Pennsylvania

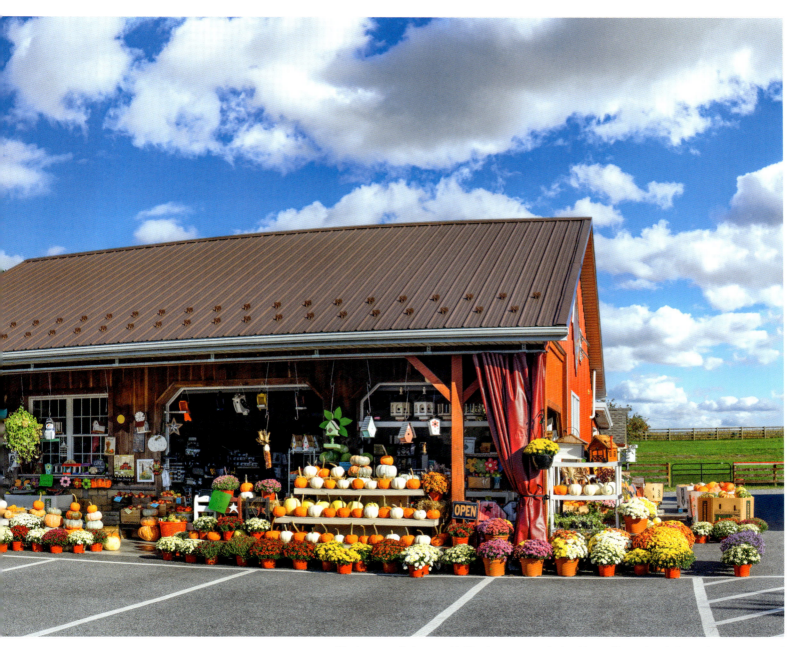

The homemade jams and jellies here are worth the drive to Pennsylvania from wherever you are!

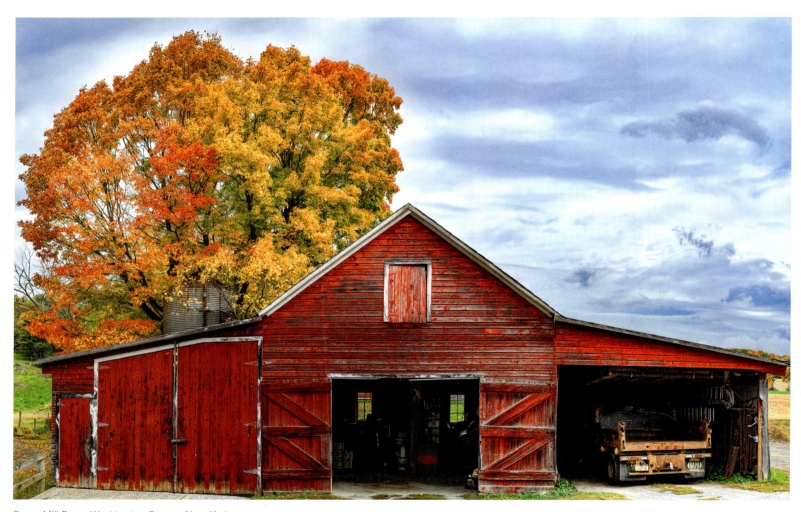

Sugar Mill Farm, Washington County, New York

New York

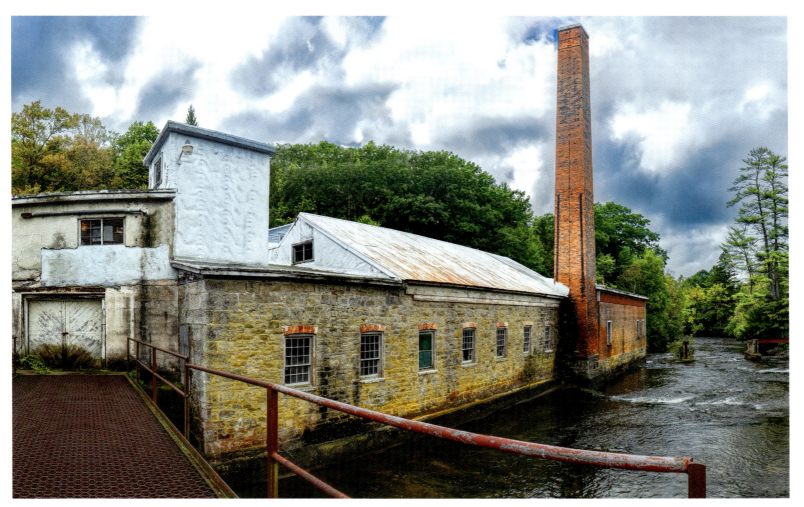

Old Mill in Rock City Falls, New York

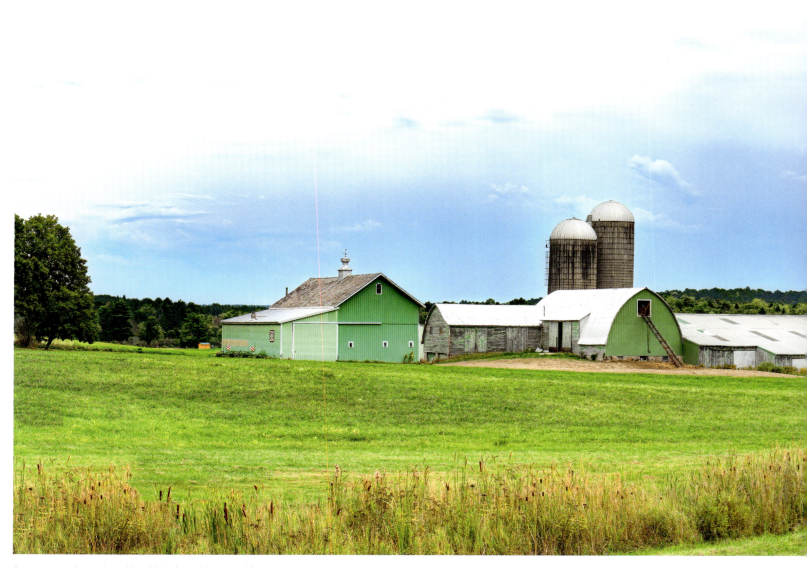

A rare green barn along New York State Highway 29

New York

There are many theories about why so many farmers paint their barns red.
My personal favorite is the one that says they do it so the cows can find their way home.

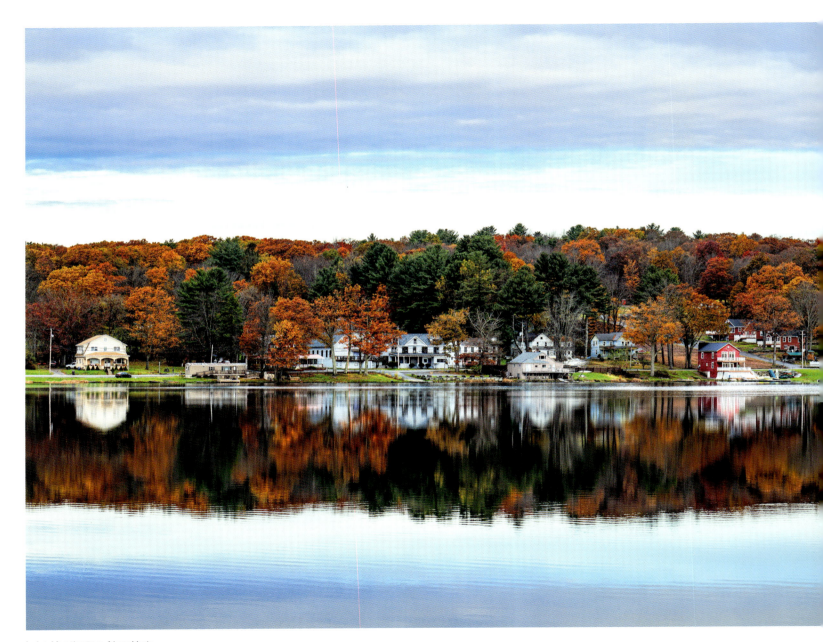
Lake Huntington, New York

New York

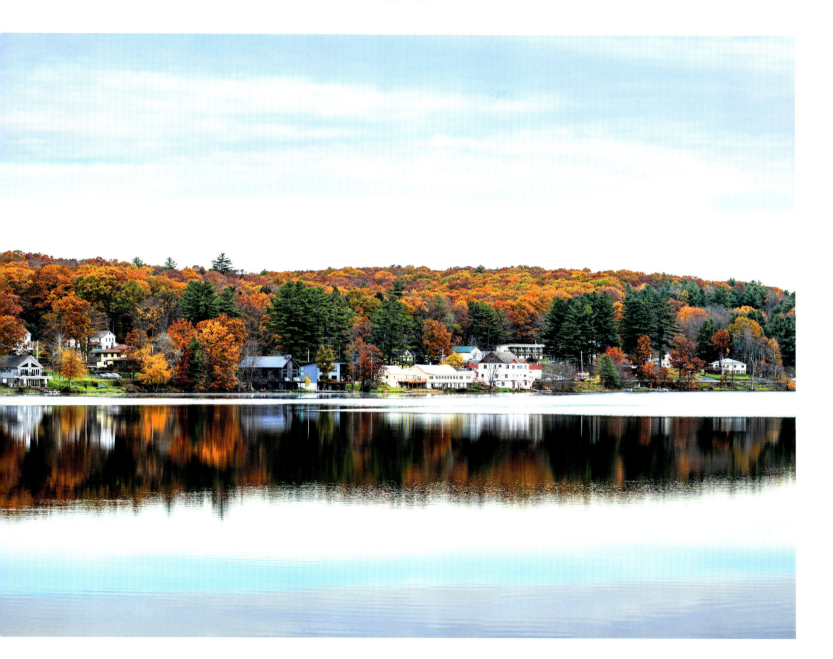

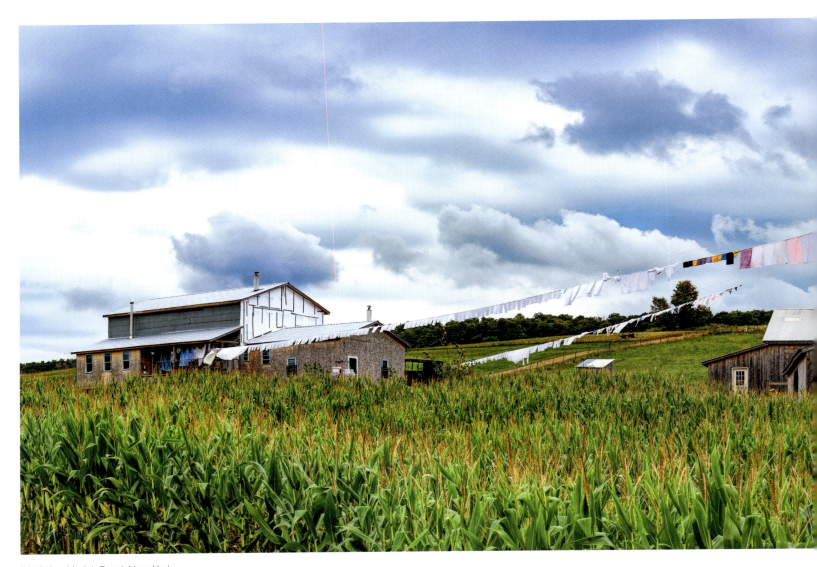

Washday, Vrolyk Road, New York

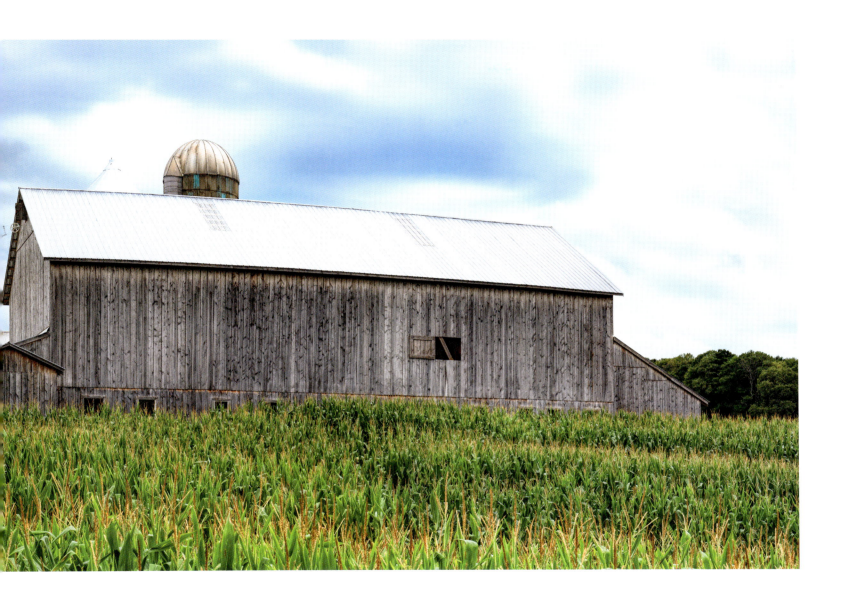

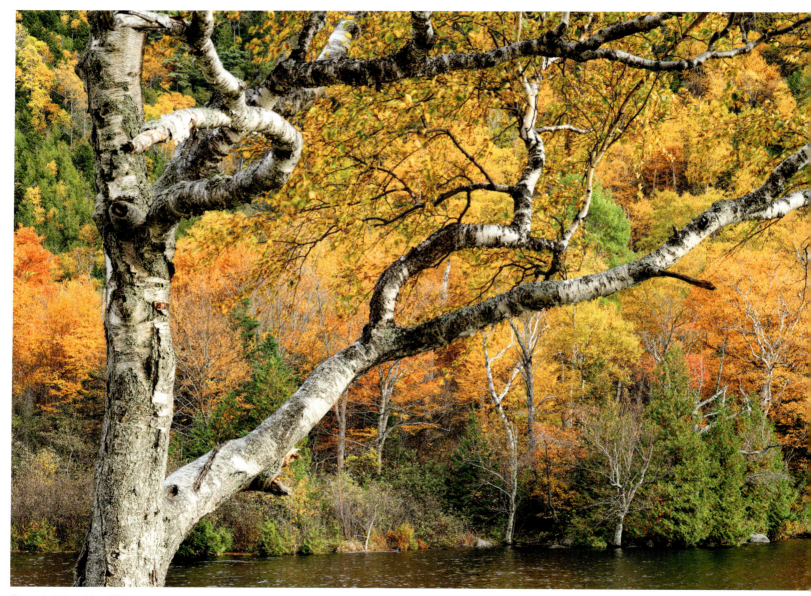

Cascade Lakes, New York

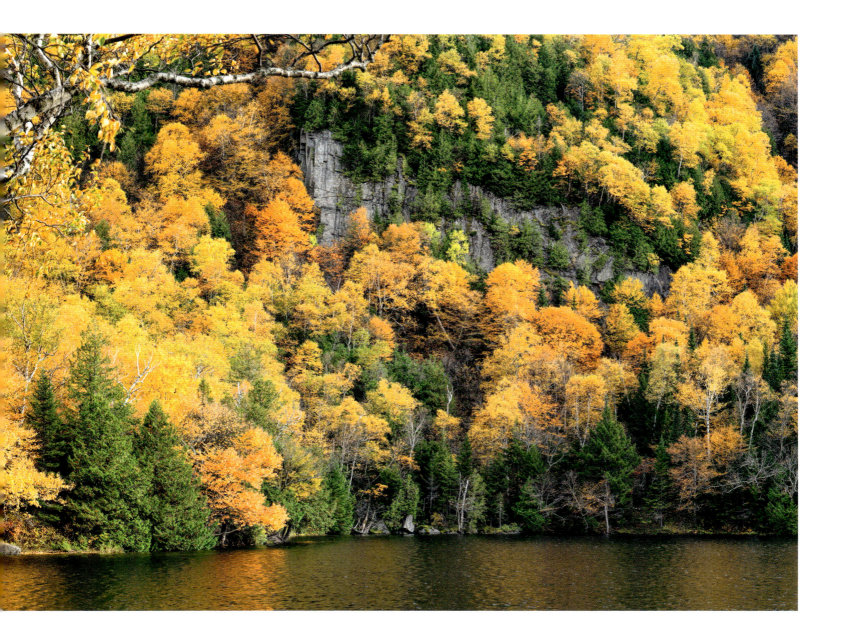

Back Roads of the Mid-Atlantic States

Villa Vosilla, Tannersville, New York, Catskill Mountains

Comedians such as Milton Berle, Henny Youngman, and Jerry Lewis got their starts in resorts like this.

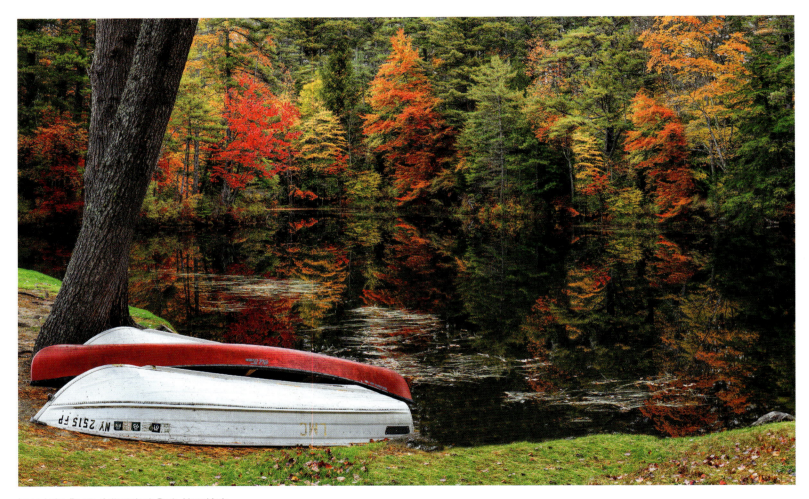

Loon Lake Boats, Adirondack Park, New York

New York

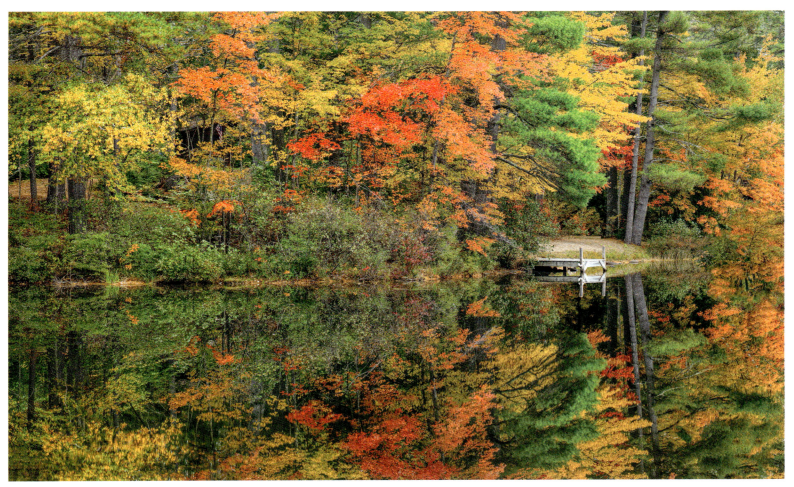

Loon Lake, Adirondack Park, New York

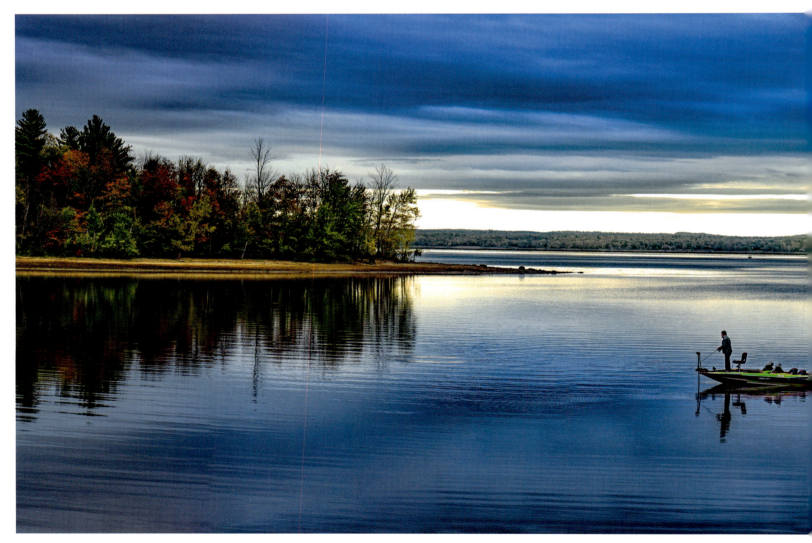

Great Sacandaga Lake, New York

New York

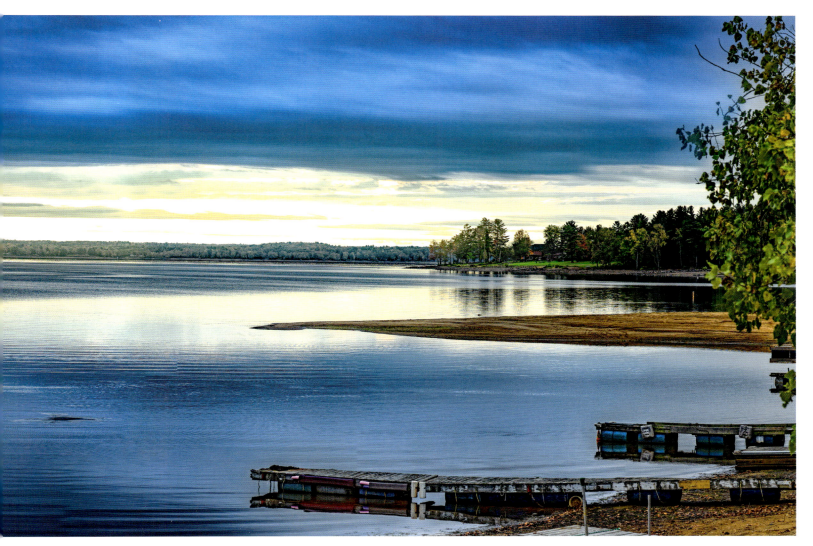

I yelled to these guys to hold as still as they could for a minute, and they did! Thanks!

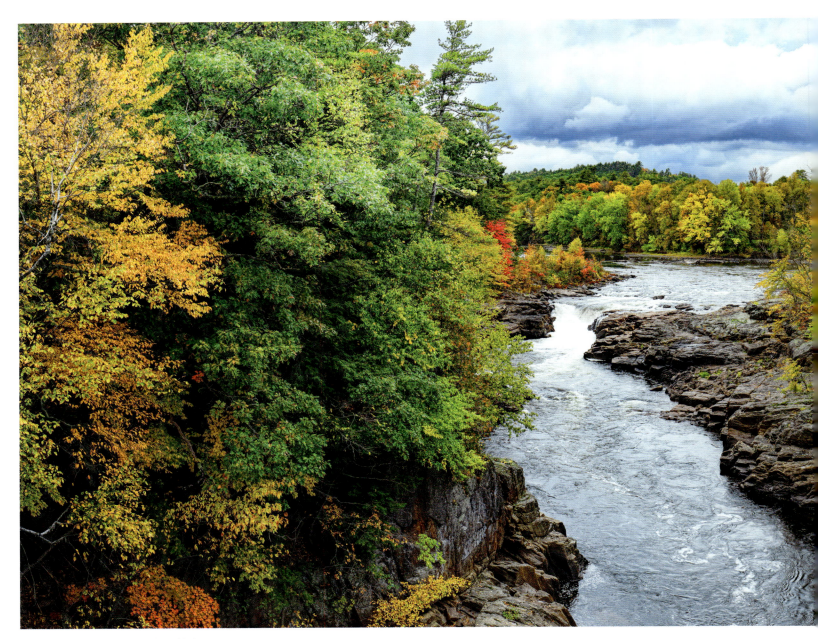

Hudson River, Lake Luzerne, New York

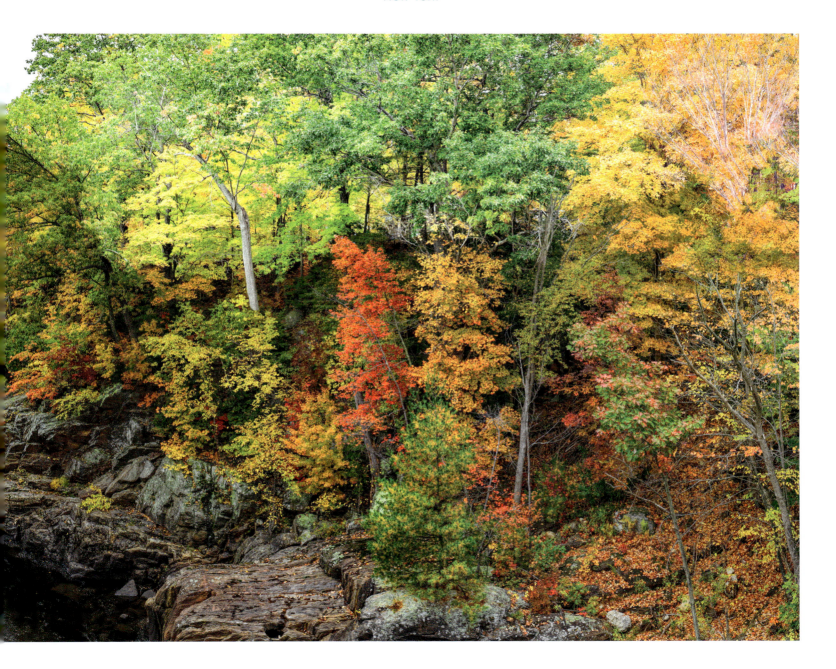

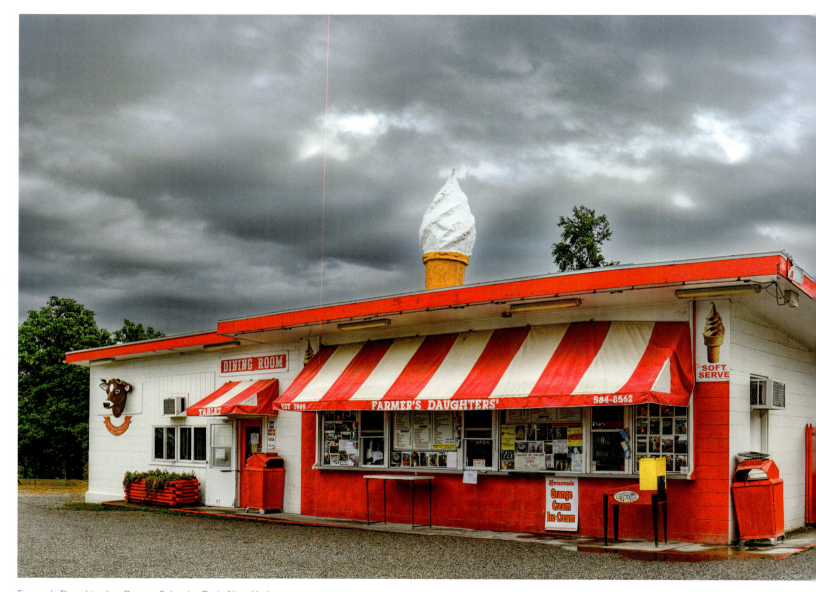

Farmer's Daughter Ice Cream, Schuyler Park, New York

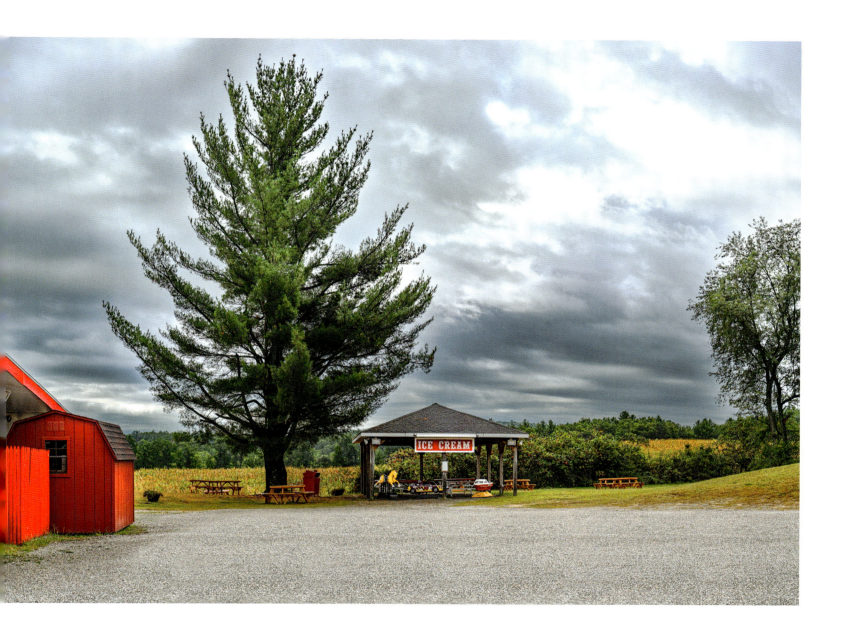

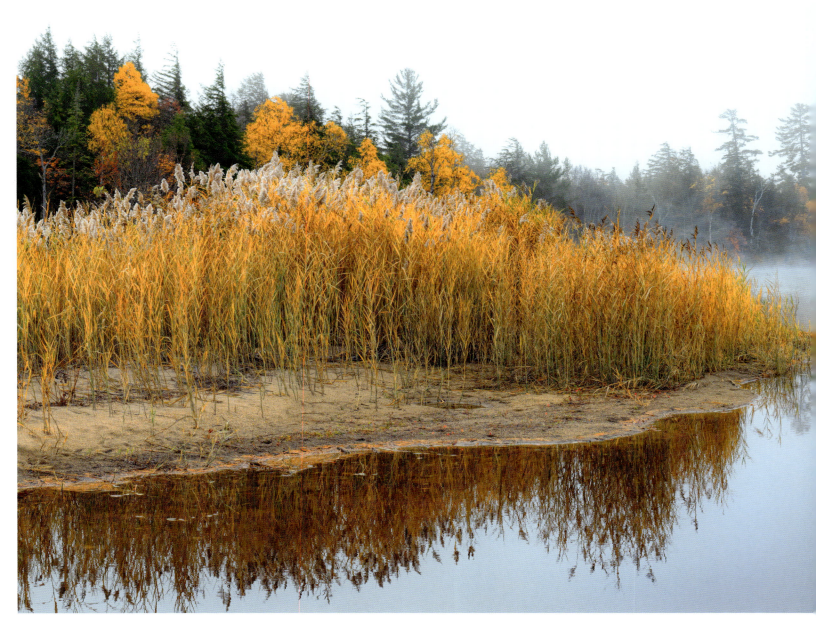

Sacandaga Lake, New York

New York

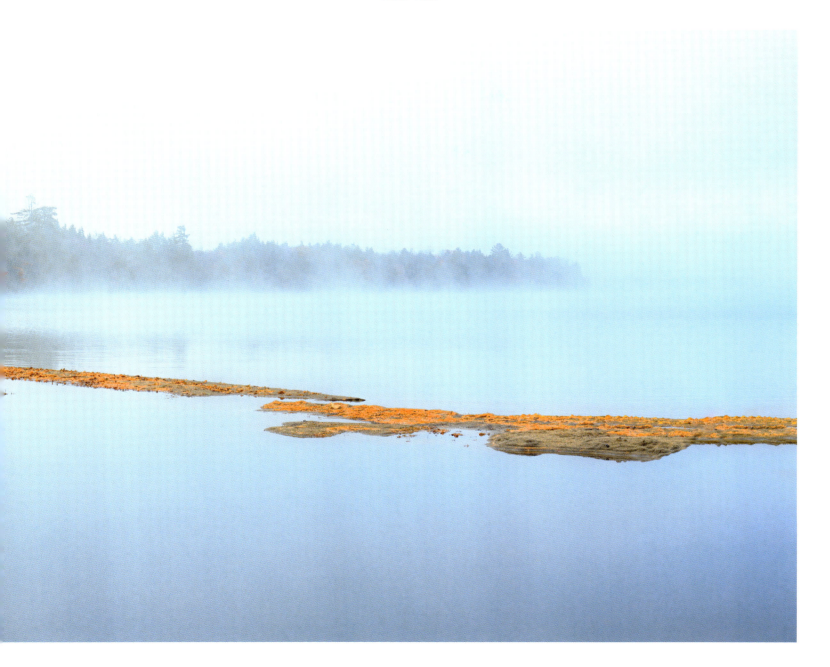

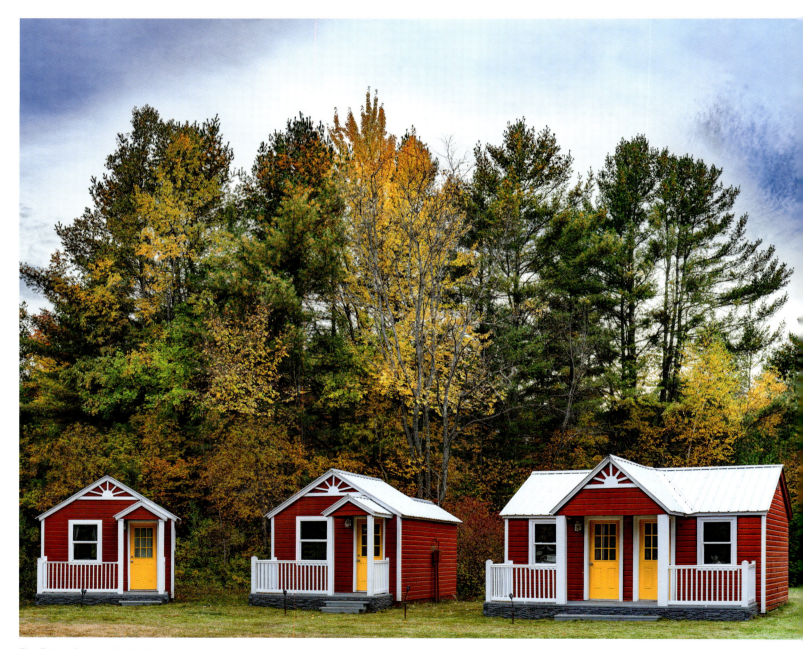

The Ember Cabins, North Hudson, New York

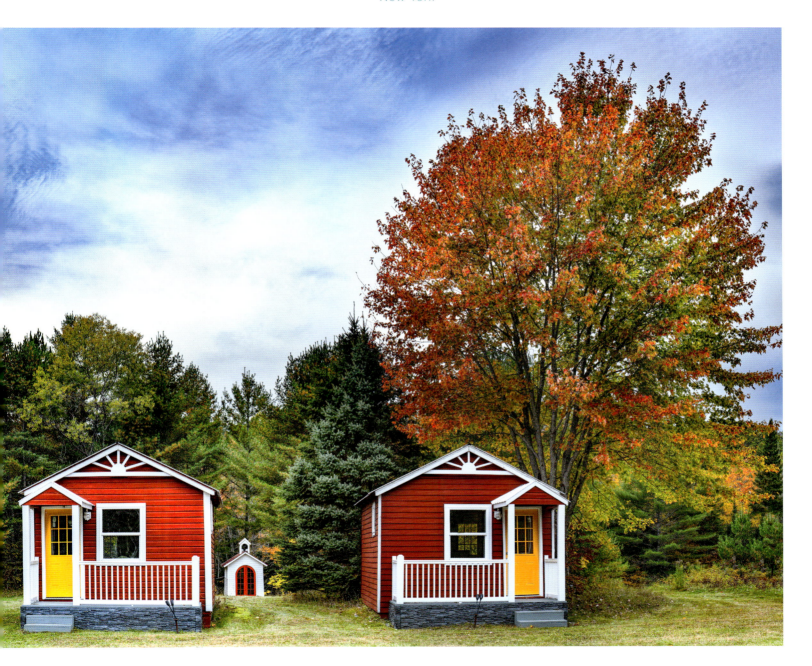

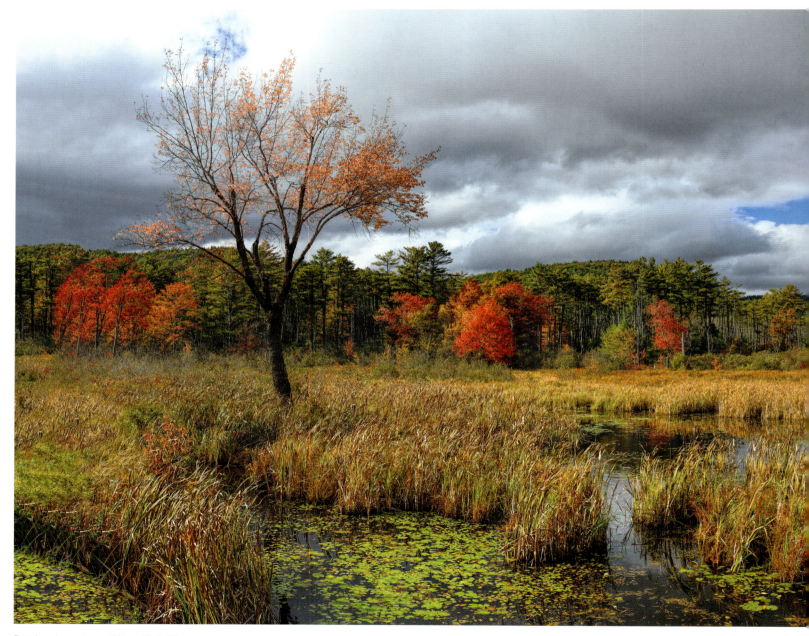

Pond and meadow off New York 9N

New York

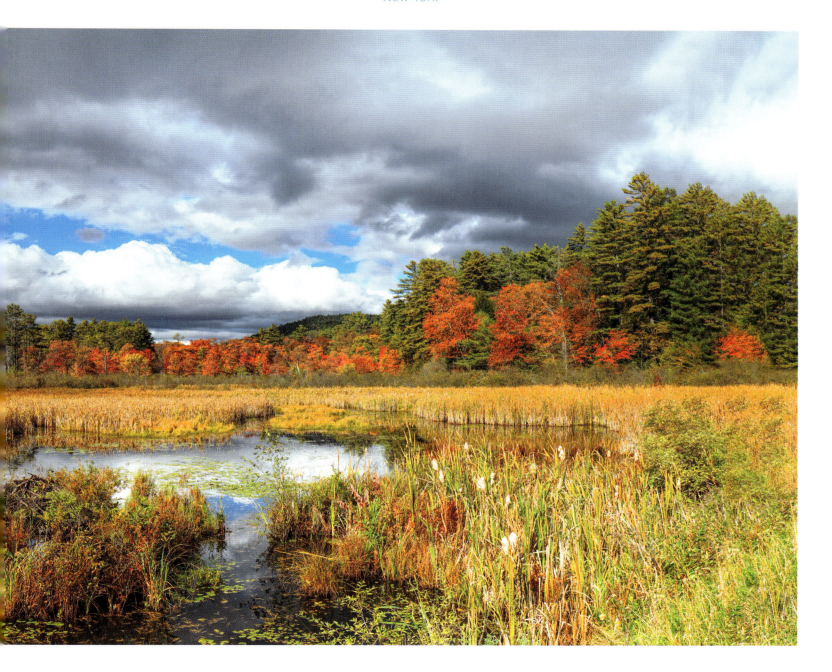

Back Roads of the Mid-Atlantic States

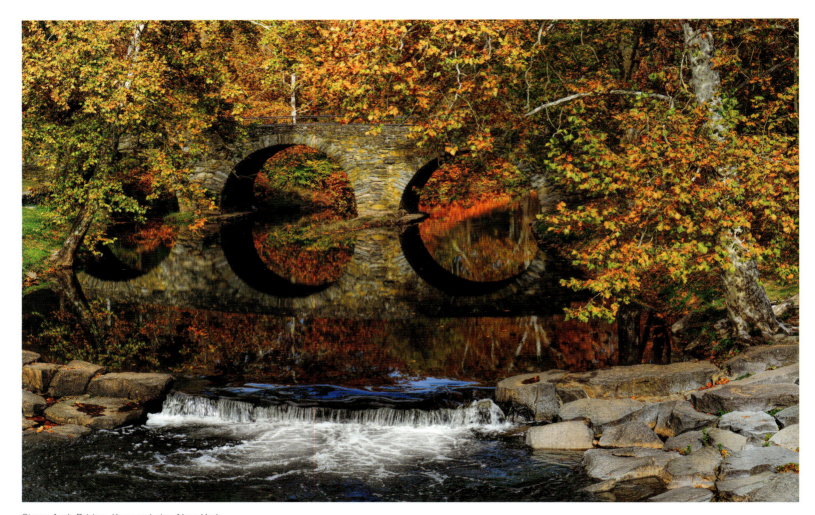

Stone Arch Bridge, Kenoza Lake, New York

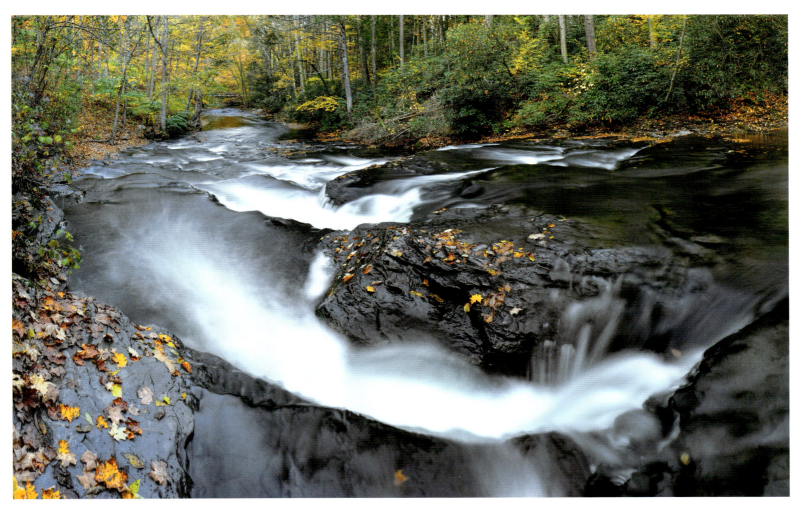

Delaware River, Delaware Water Gap National Recreation Area, New Jersey

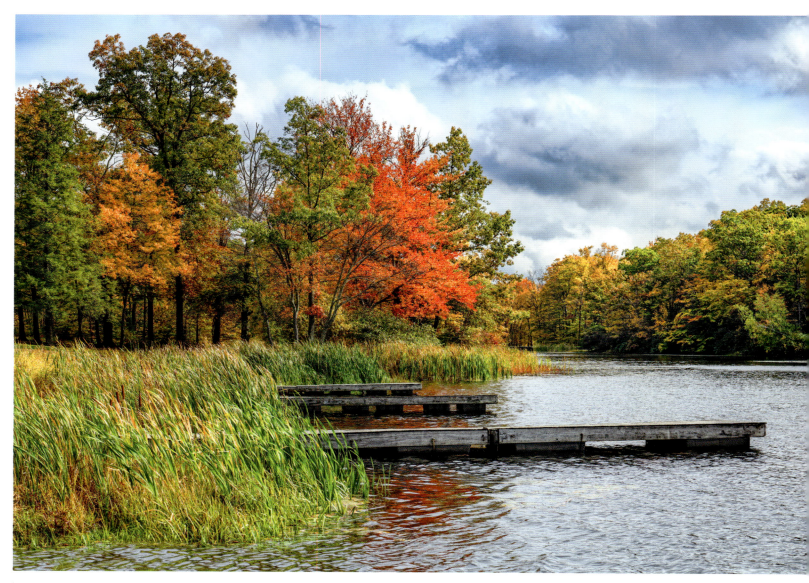
Wawayanda Lake, Highland Lakes, New Jersey

New Jersey

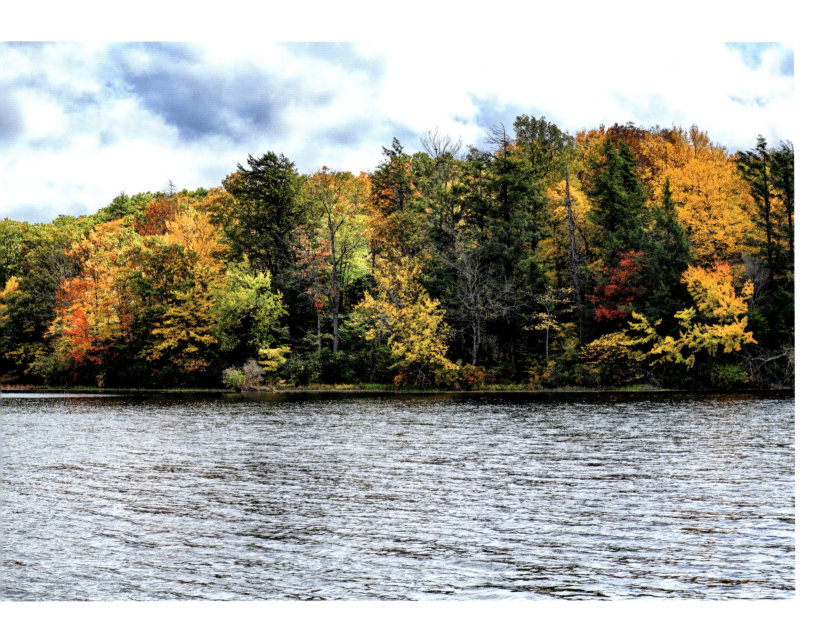

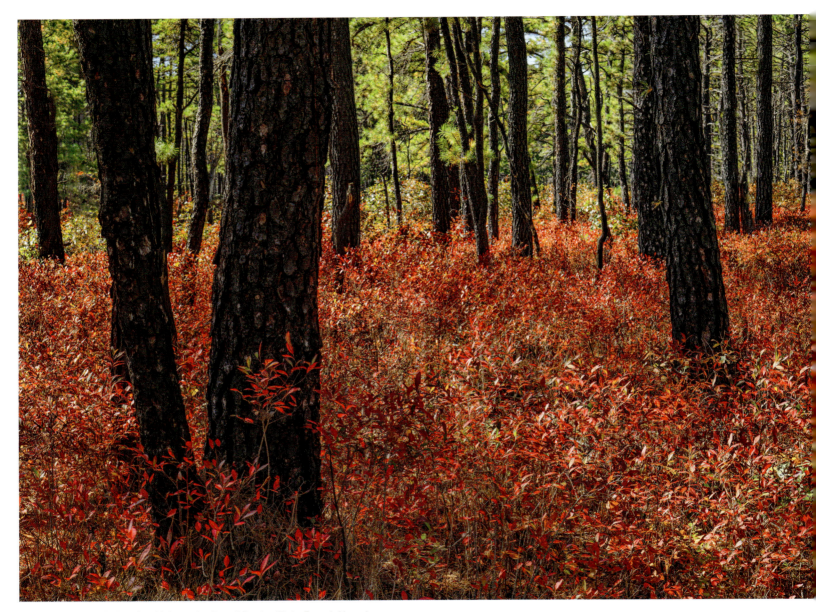

Pine trees and wild black huckleberry bushes, Wharton State Forest, New Jersey

New Jersey

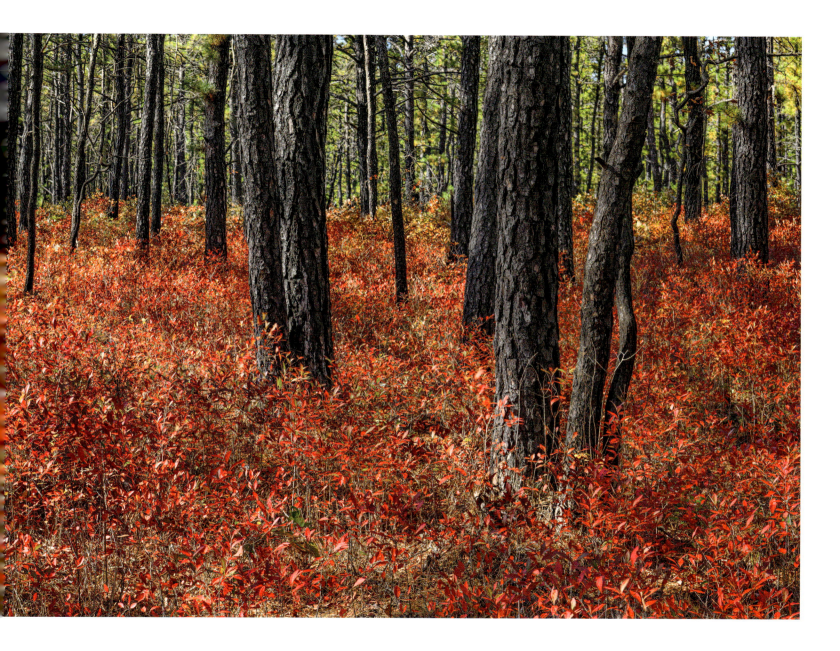

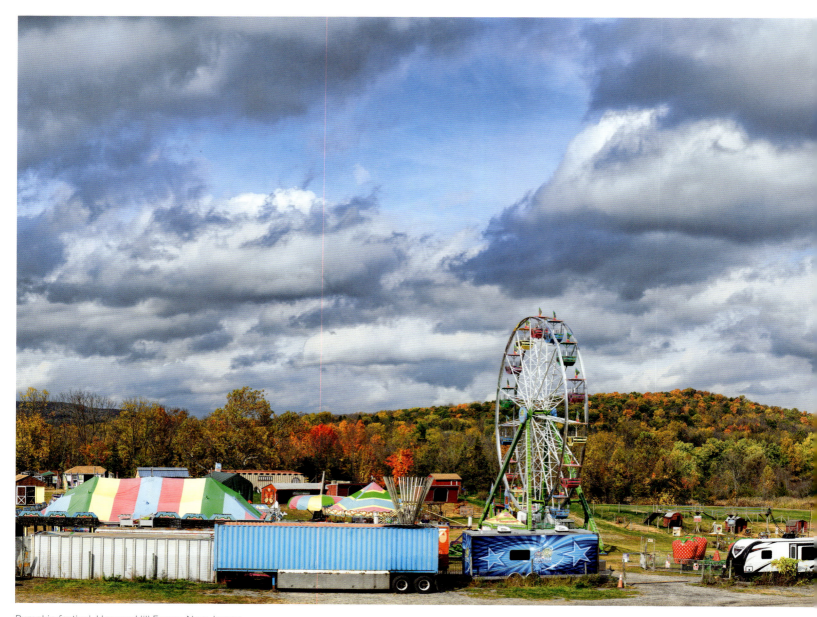
Pumpkin festival, Heaven Hill Farms, New Jersey

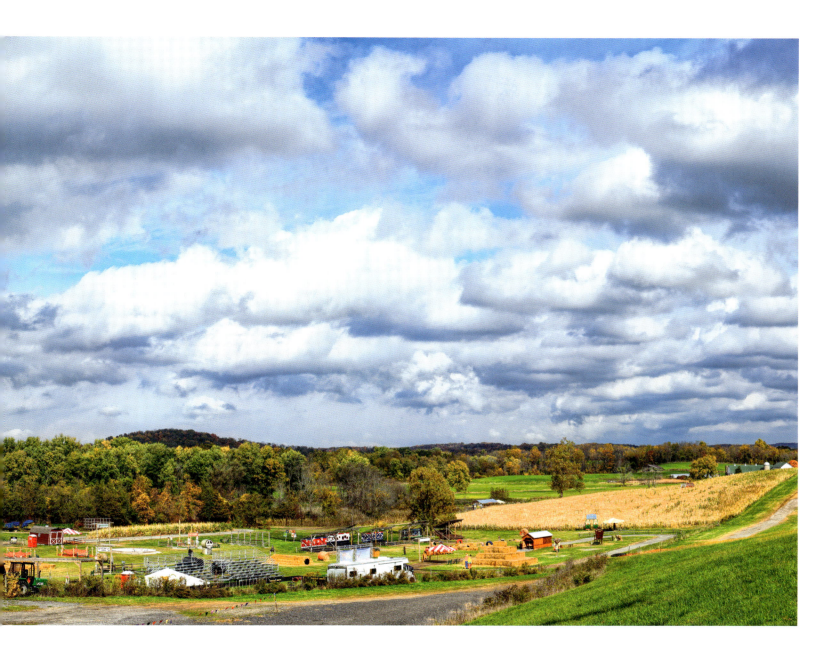

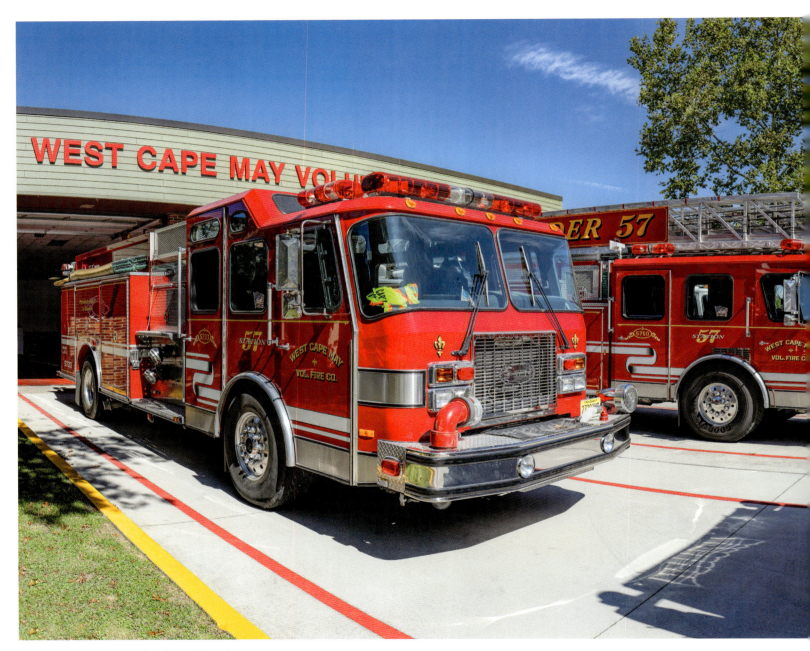

West Cape May Volunteer Fire Station, New Jersey

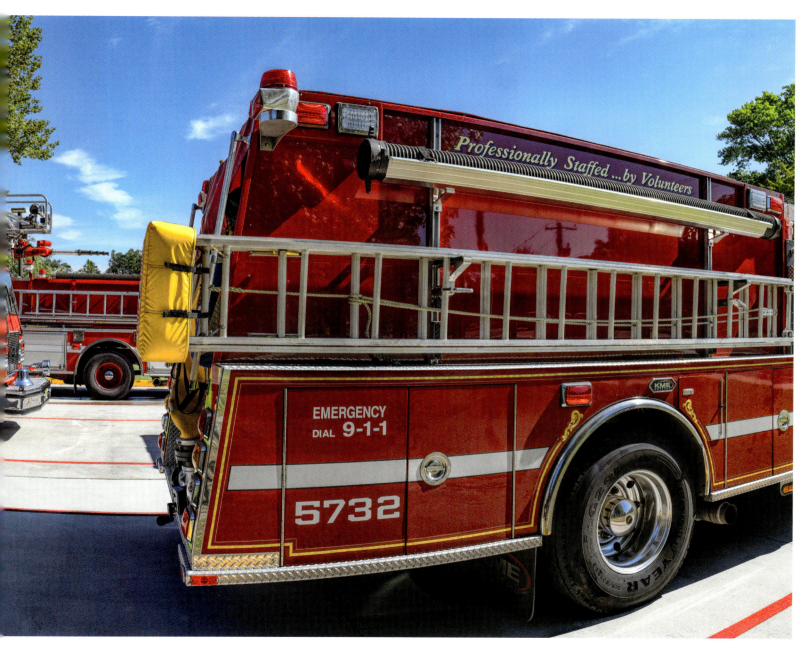

There are 687 volunteer fire departments in the small state of New Jersey. I am sure they are all "Professionally Staffed... by Volunteers."

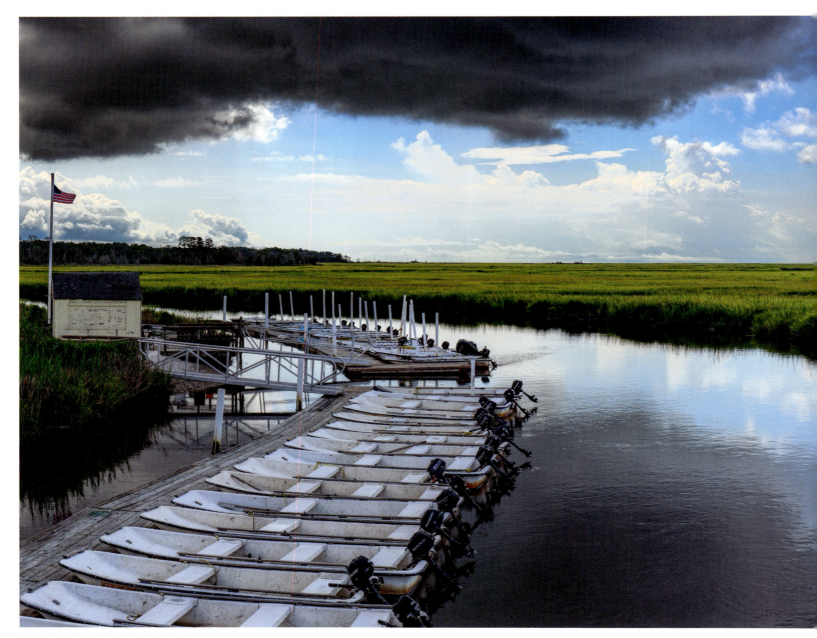
Dividing Creek Boat Rentals, New Jersey

New Jersey

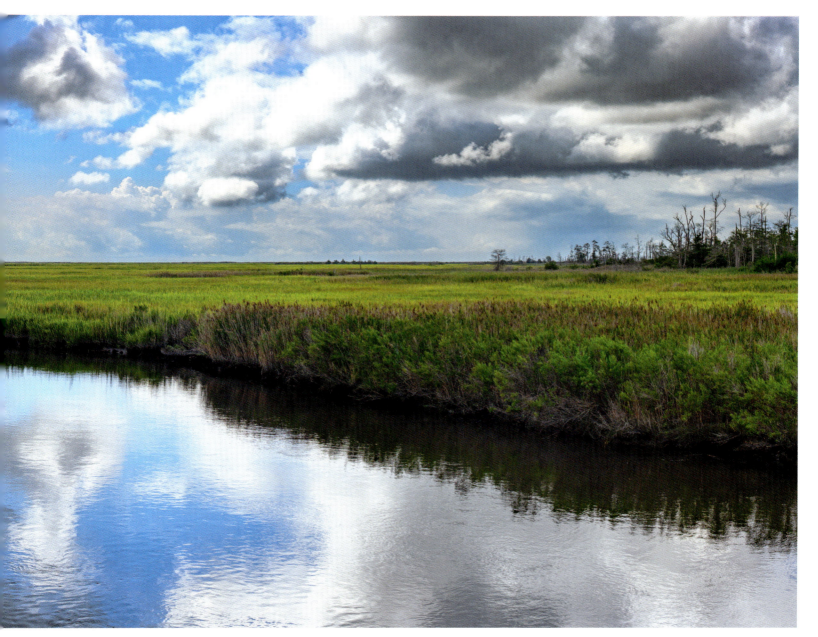

A sign here proclaims, "I caught my crabs at Dividing Creek Boat Rentals."

Back Roads of the Mid-Atlantic States

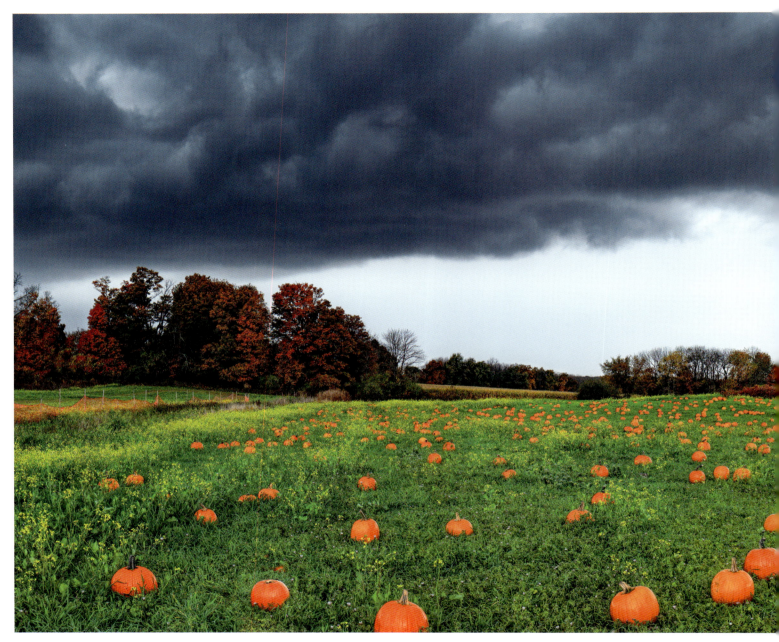

Pumpkins at Lentini Farms, New Jersey

New Jersey

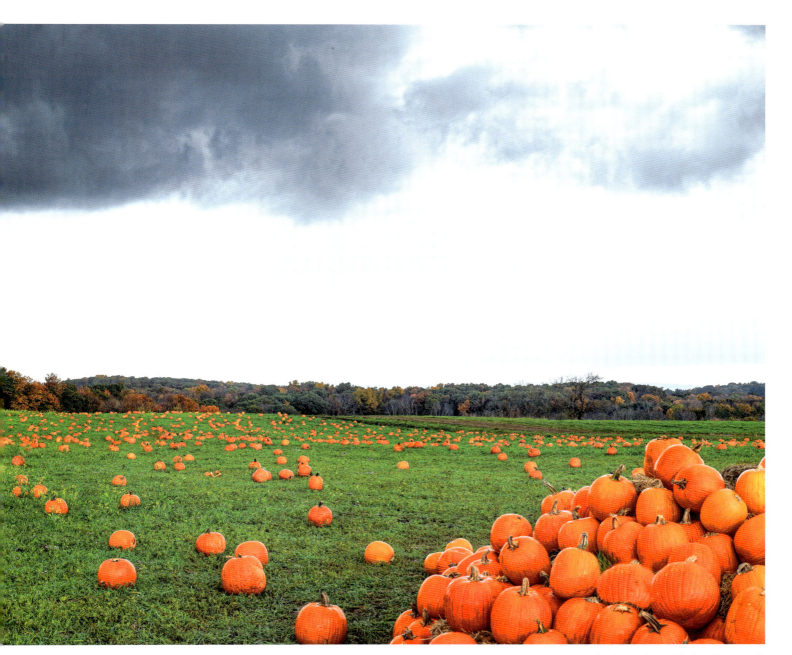

I couldn't help imagining this field full of kids, but it was raining hard that day so I had it all to myself.

Back Roads of the Mid-Atlantic States

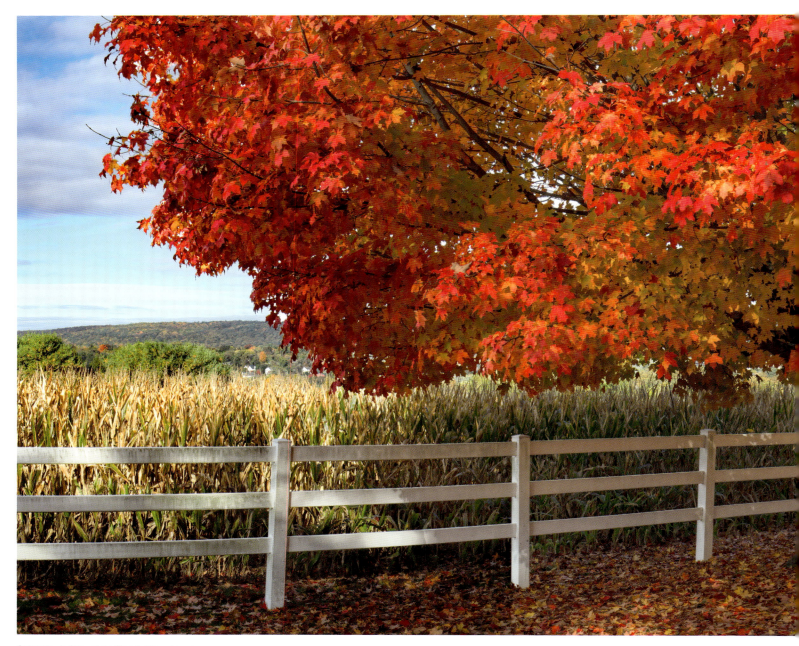

Schooley's Mountain Road, New Jersey

New Jersey

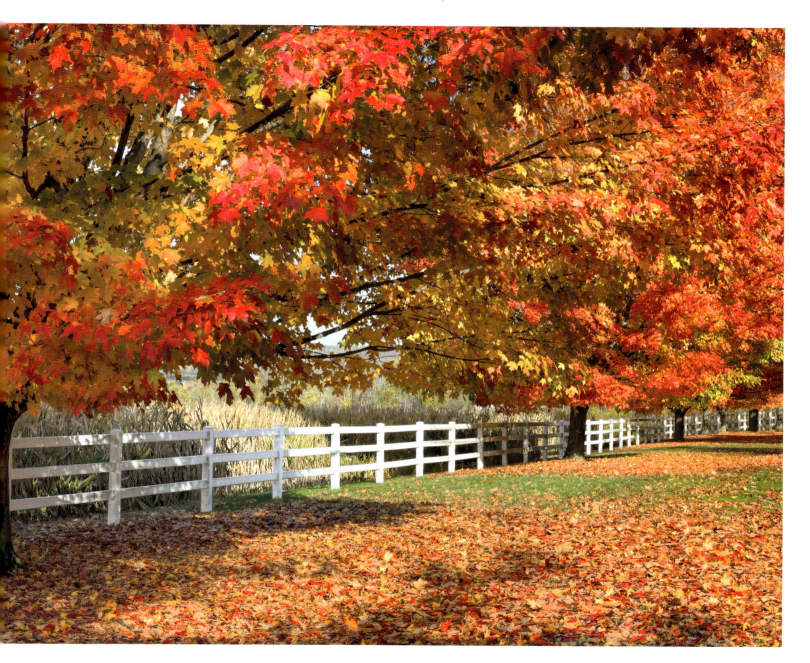

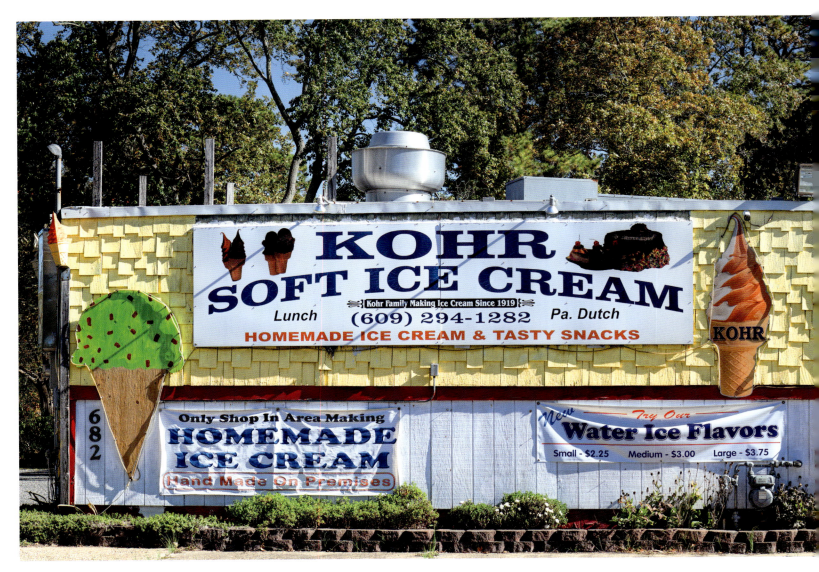

Kohr Ice Cream, Tuckerton, New Jersey

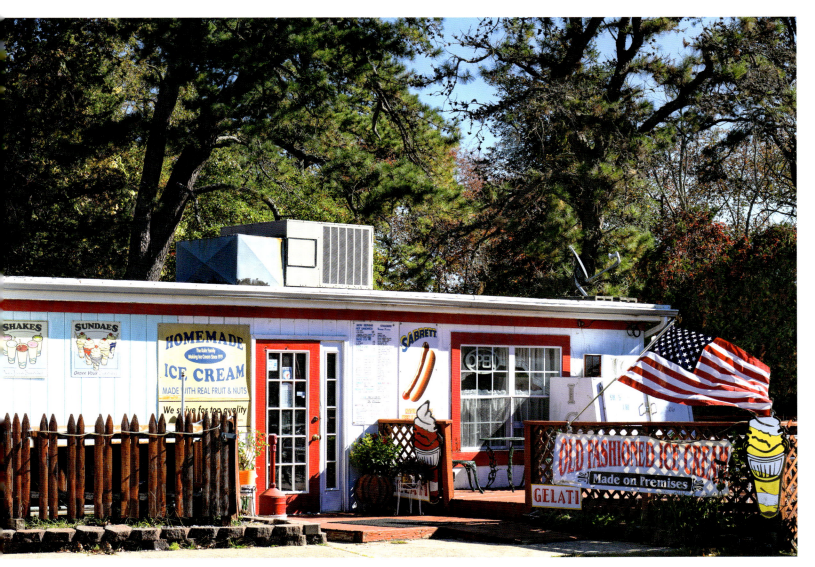

If I am ever within 100 miles of this place, I'm going back!

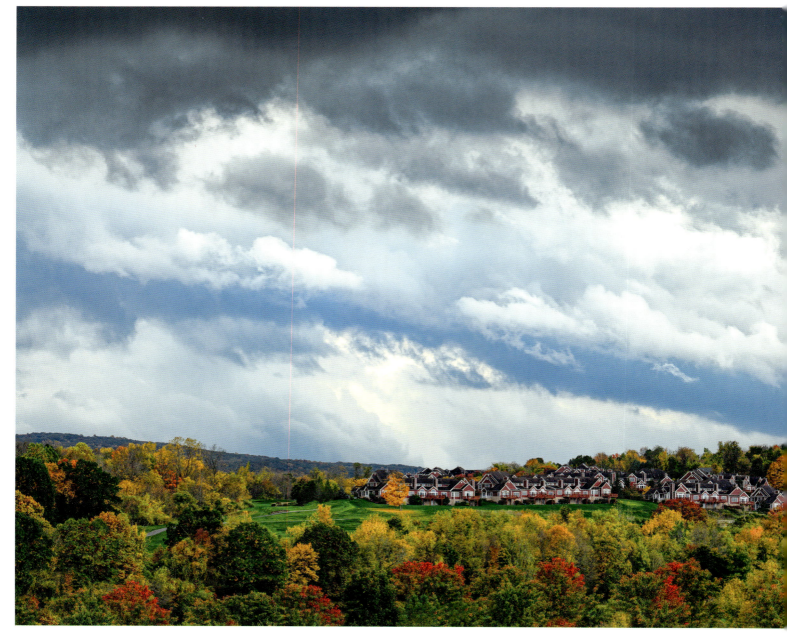

Village of Crystal Springs, New Jersey

New Jersey

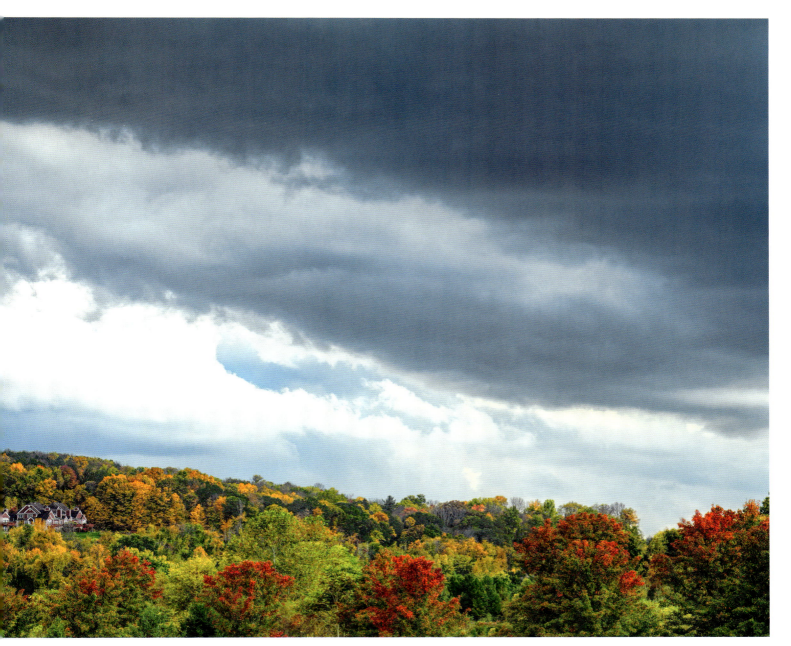

If you lived here, you'd be home by now.

Back Roads of the Mid-Atlantic States

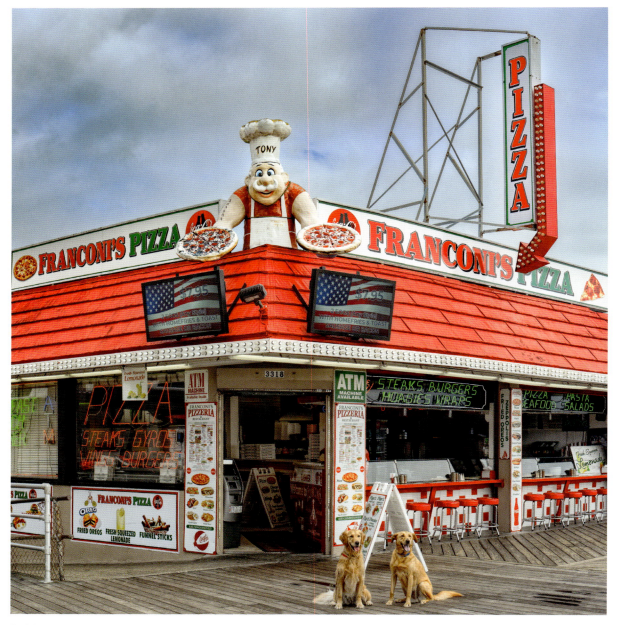

Buddy and Ryleigh at Franconi's Pizza on the Wildwood boardwalk, New Jersey

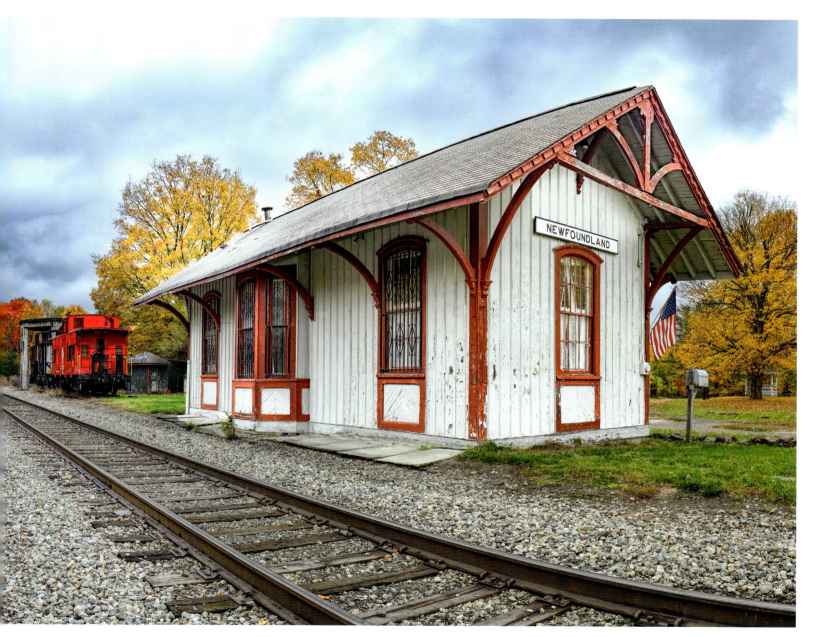

Newfoundland Station, New Jersey

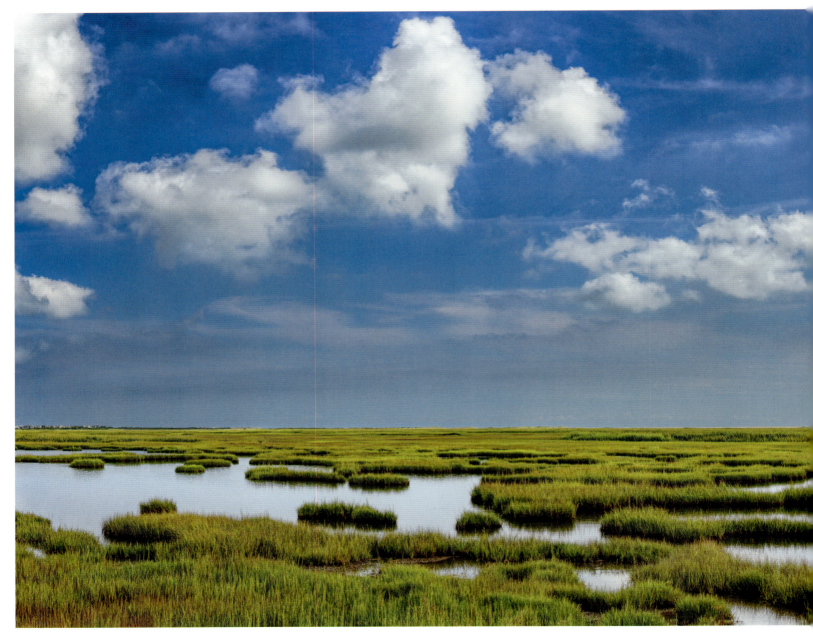

Wetlands, Golden Shores, New Jersey

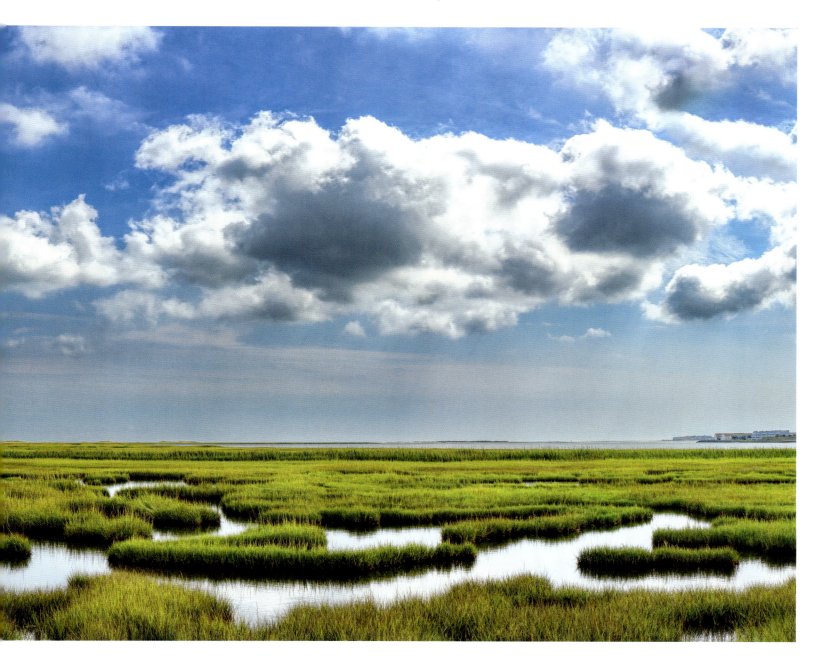

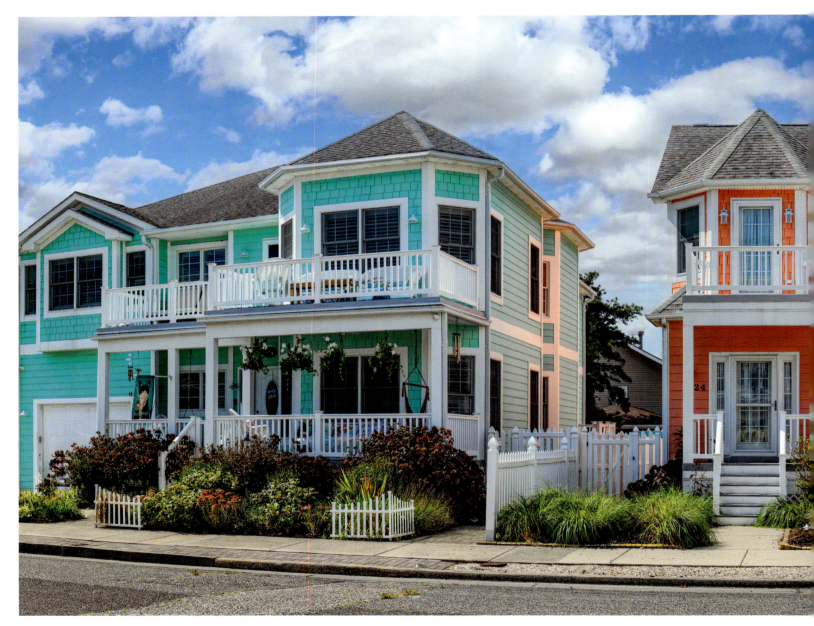

Cardinal Road, Wildwood, New Jersey

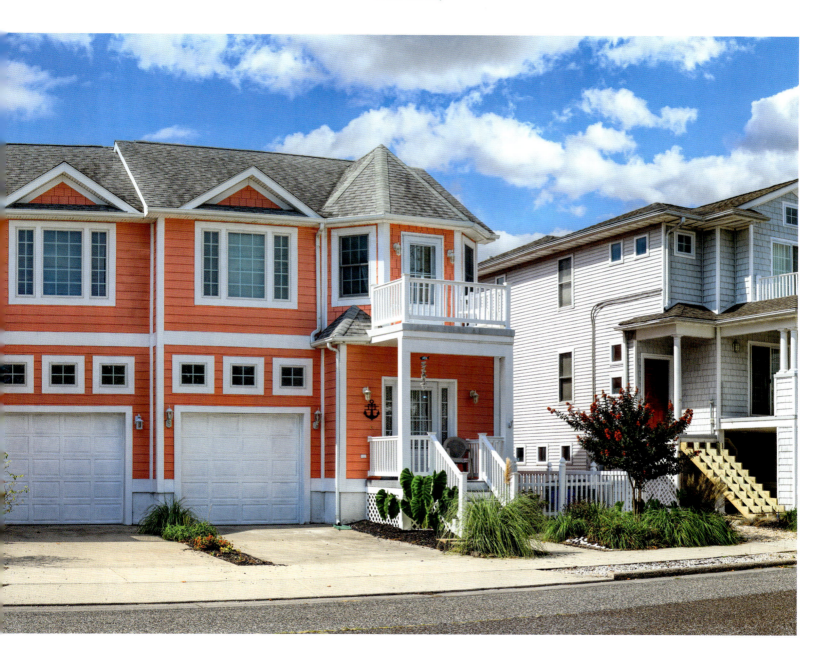

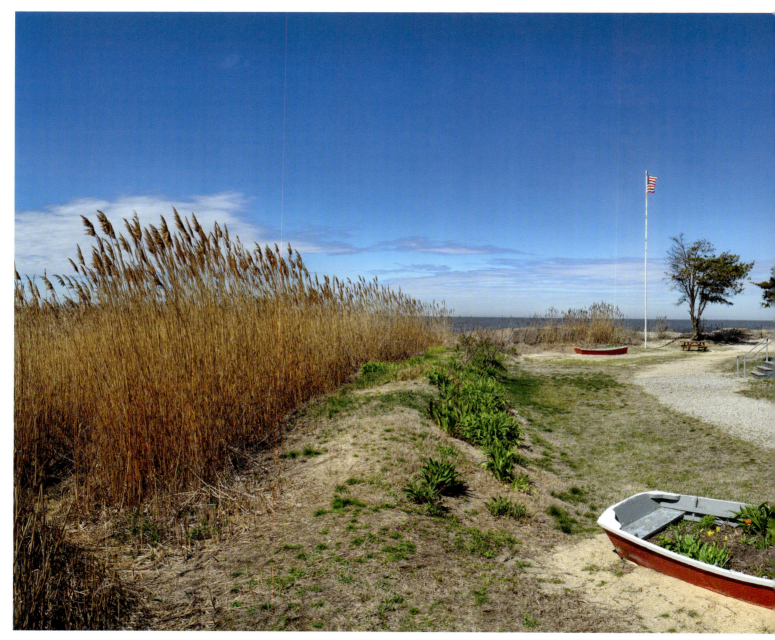

East Point Lighthouse, New Jersey

New Jersey

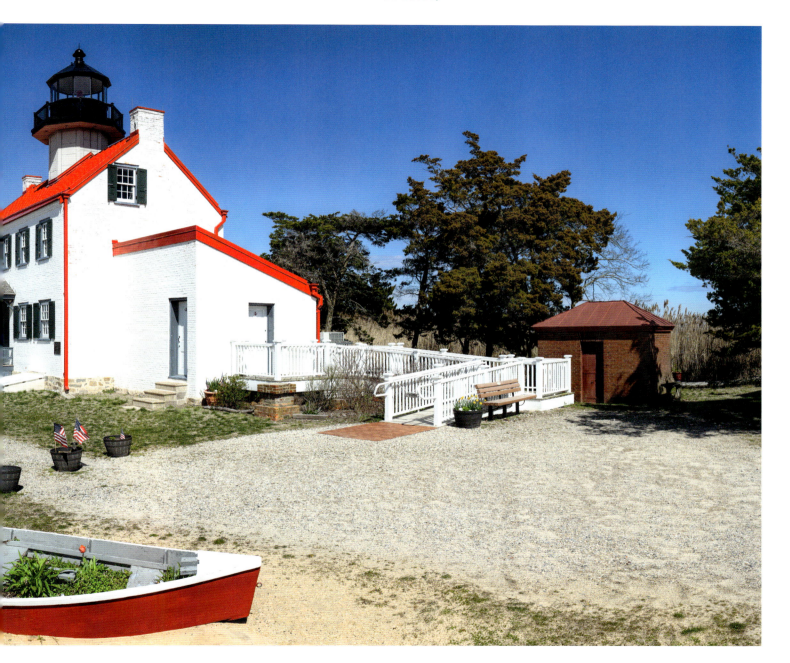

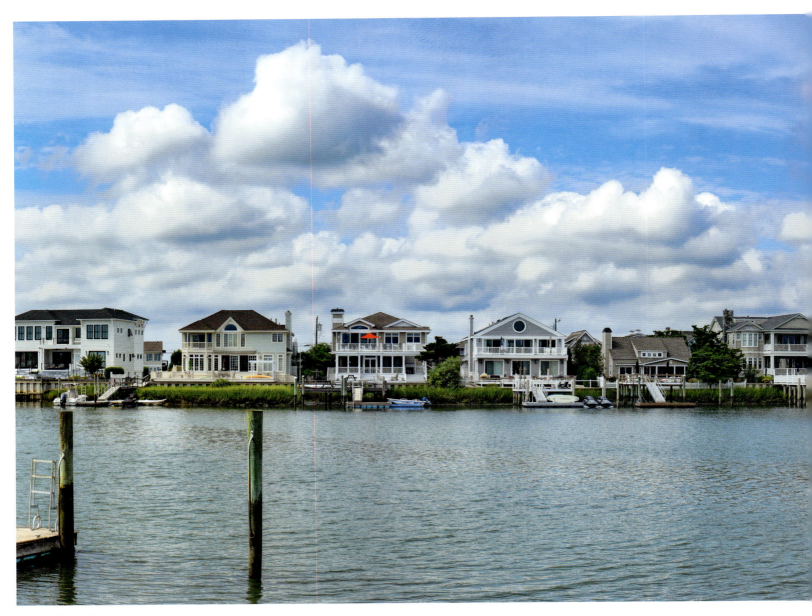

Carnival Cove, New Jersey

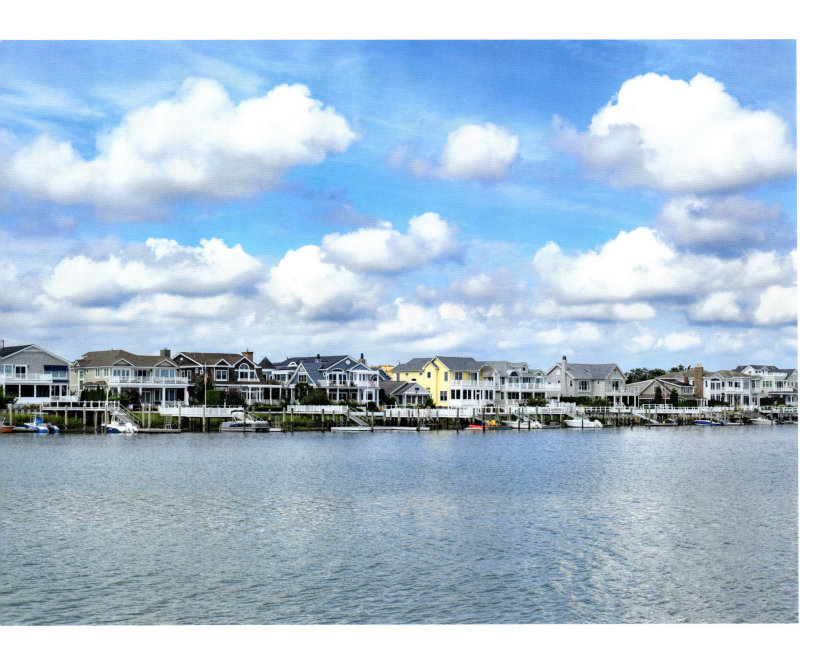

Back Roads of the Mid-Atlantic States

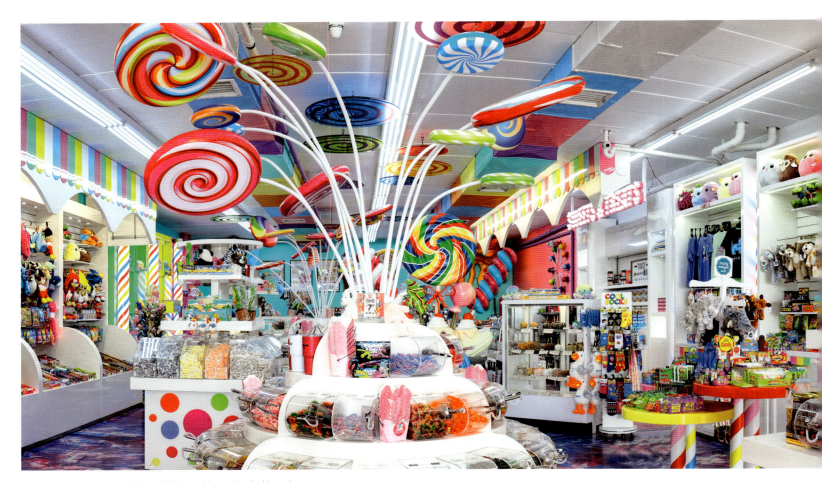

So Sweet Candy Store, North Wildwood boardwalk, New Jersey

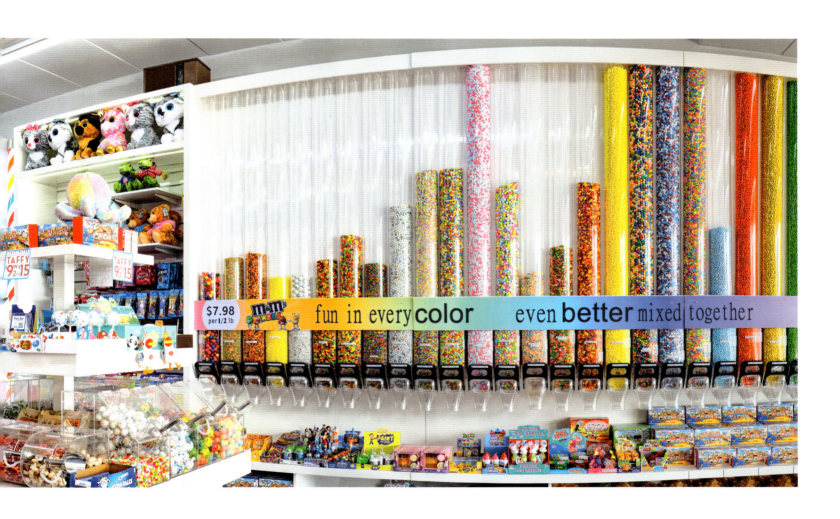

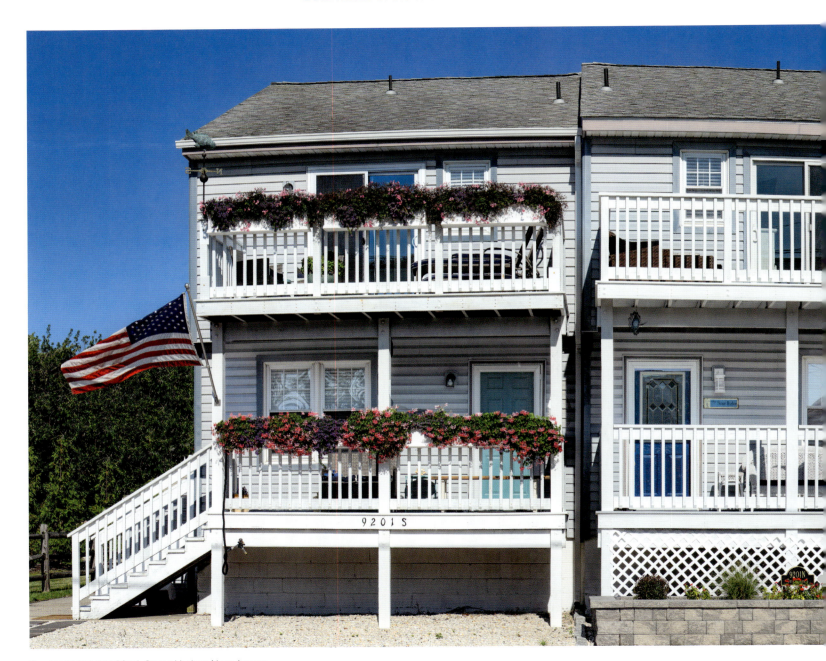

Corner of 3rd and 92nd, Stone Harbor, New Jersey

New Jersey

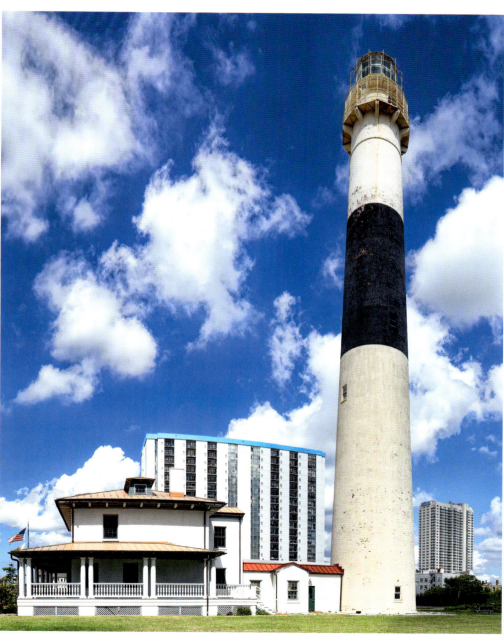

Absecon Lighthouse, Atlantic City, New Jersey

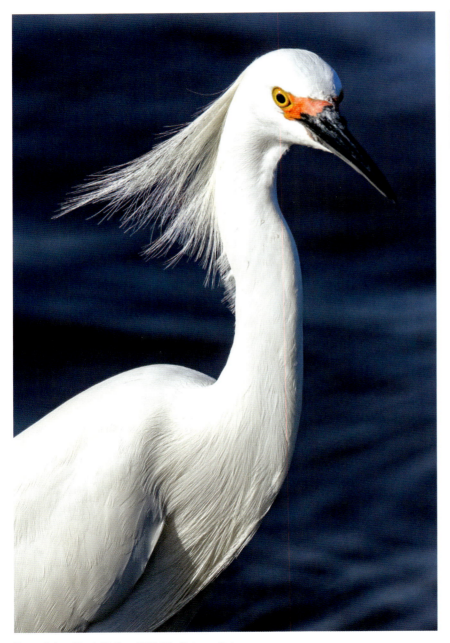

Egret, Prime Hook National Wildlife Refuge, Delaware

Delaware

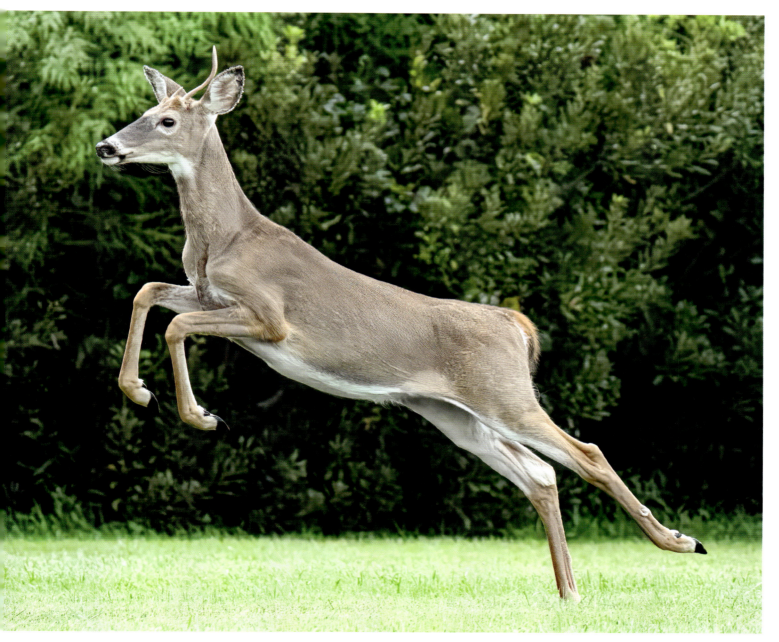

White-tailed deer, Delaware

Back Roads of the Mid-Atlantic States

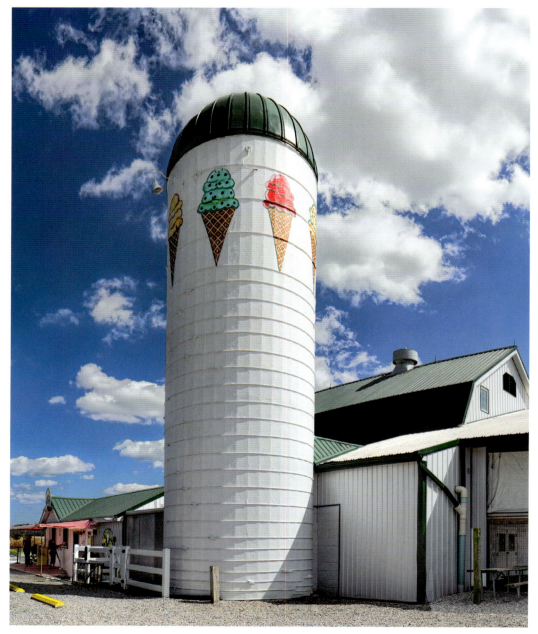

Hopkins Farm Creamery, Lewes, Delaware Really good ice cream!

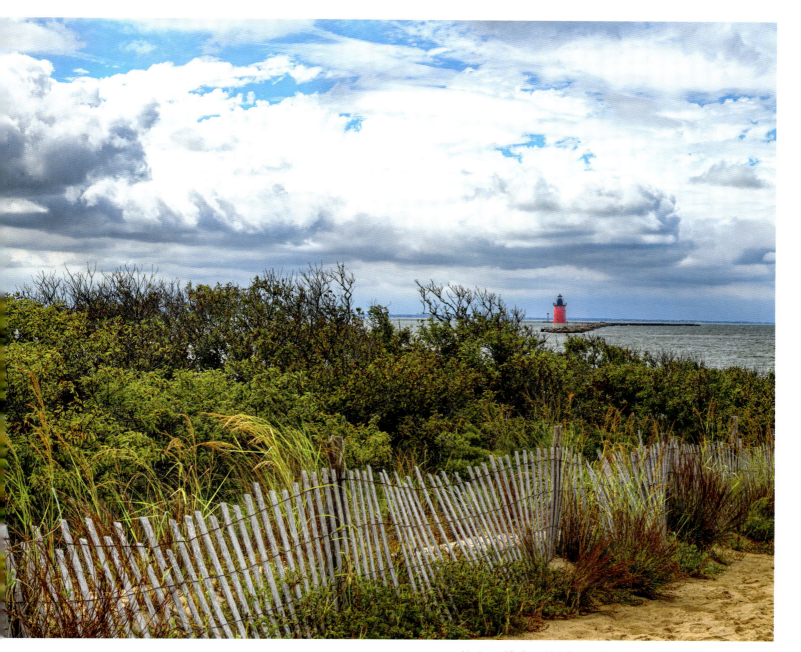
Harbor of Refuge Lighthouse, Cape Henlopen State Park, Delaware

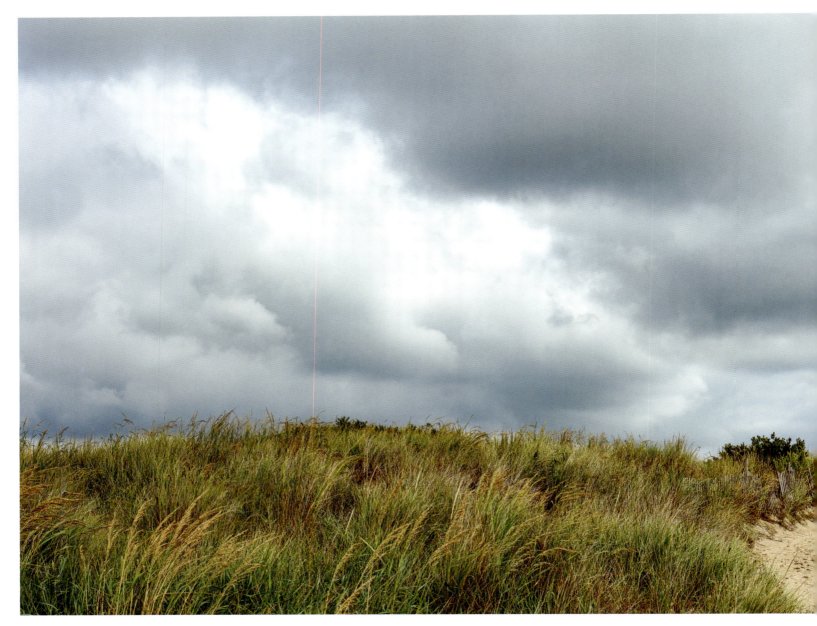

Sand dunes, Cape Henlopen State Park, Lewes, Delaware

Delaware

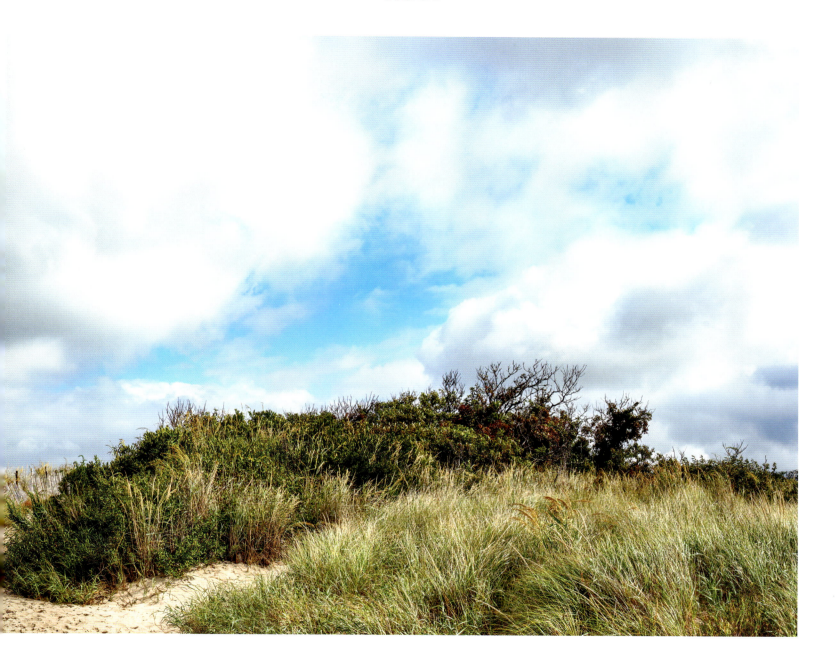

Back Roads of the Mid-Atlantic States

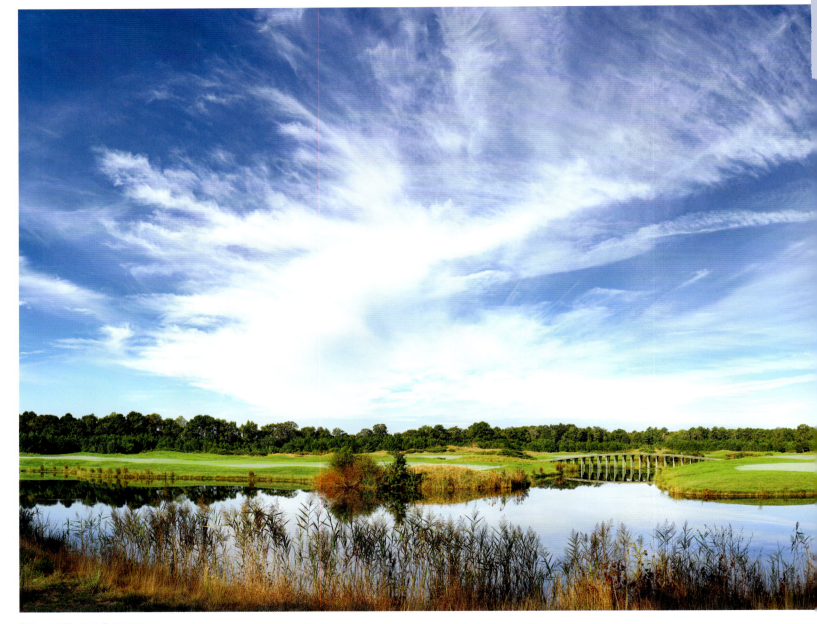

Batwood Greens, Delaware

Delaware

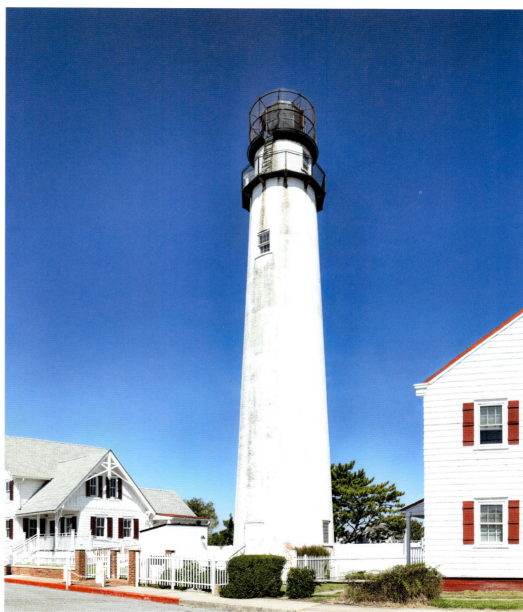

Fenwick Island Lighthouse, Delaware

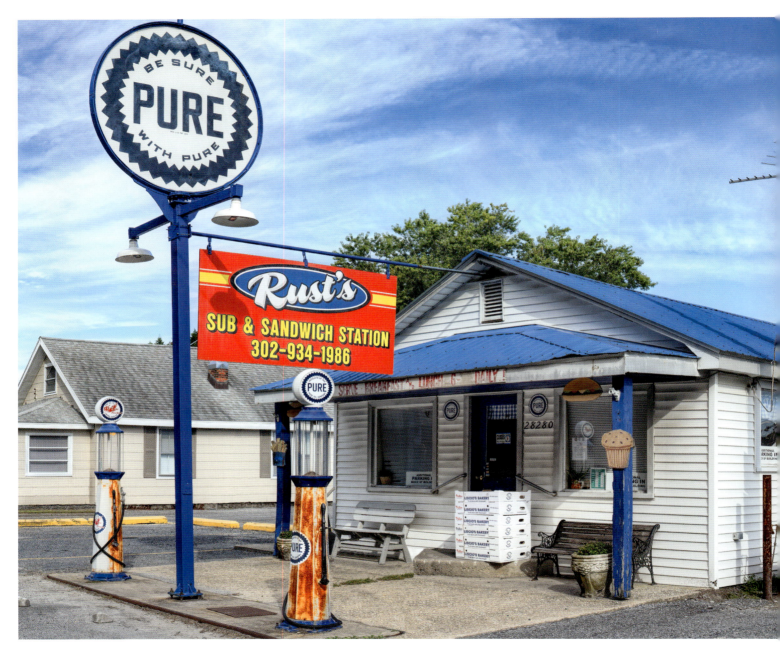

Rust's on Delaware State Highway 24, Millsboro, Delaware

1940s chicken ranch, Cowhouse Branch Road, Delaware

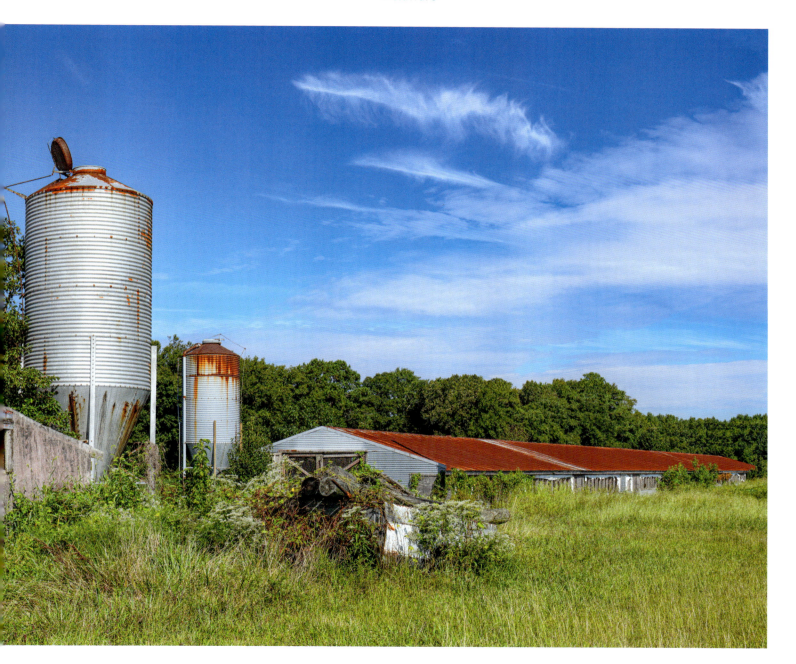

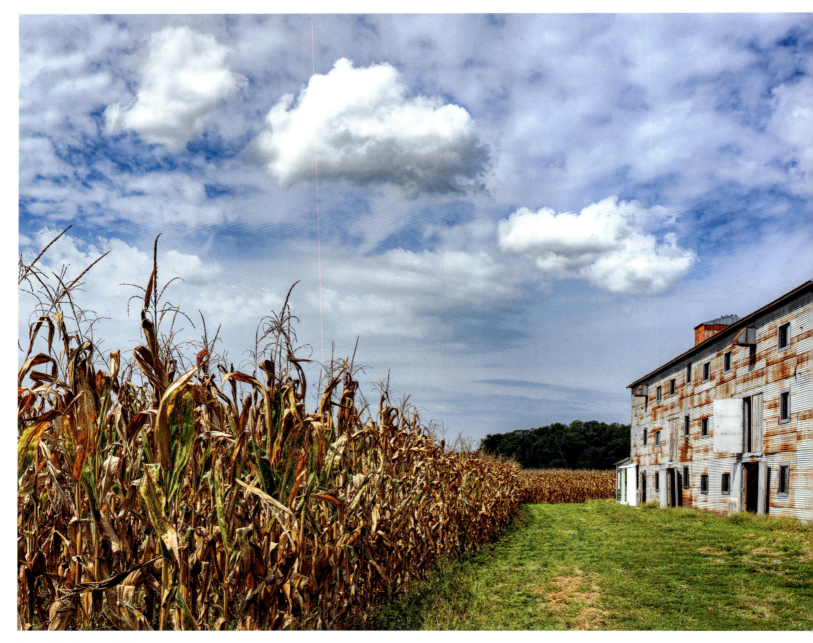
Pigeon Ranch, Laurel, Delaware

Delaware

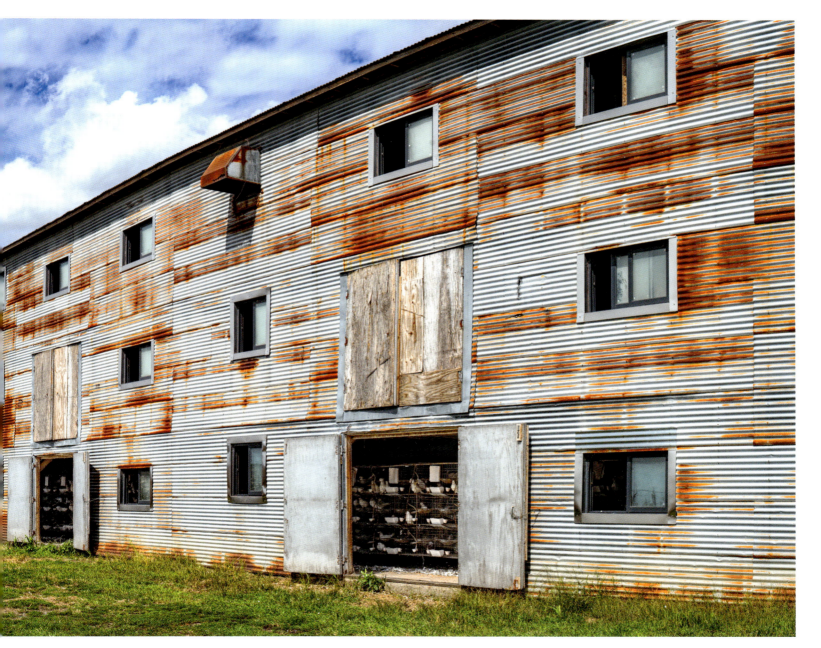

I wish you could hear the sounds that came from inside. It was mesmerizing.

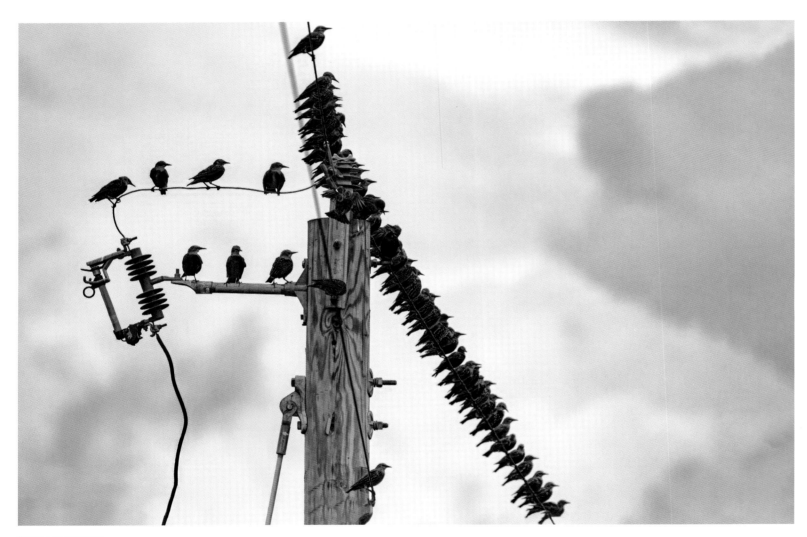
European starlings

Delaware

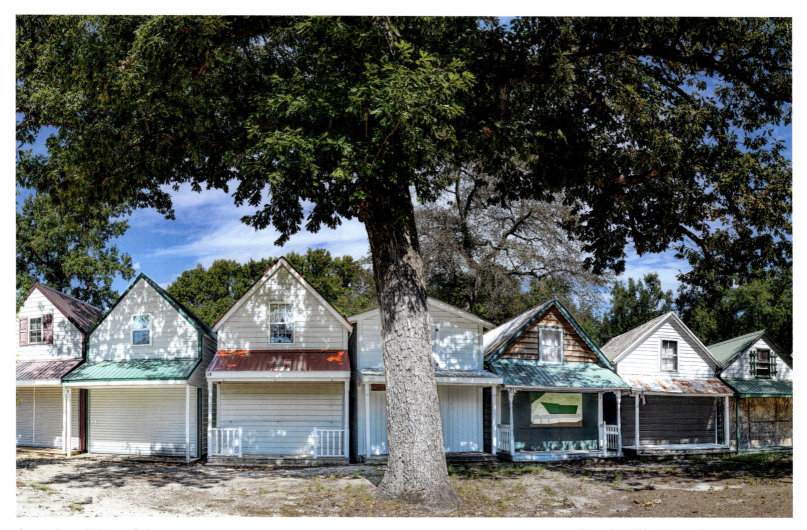

Carey's Camp, Millsboro, Delaware

Started in 1879, this revival camp is still in use.

Back Roads of the Mid-Atlantic States

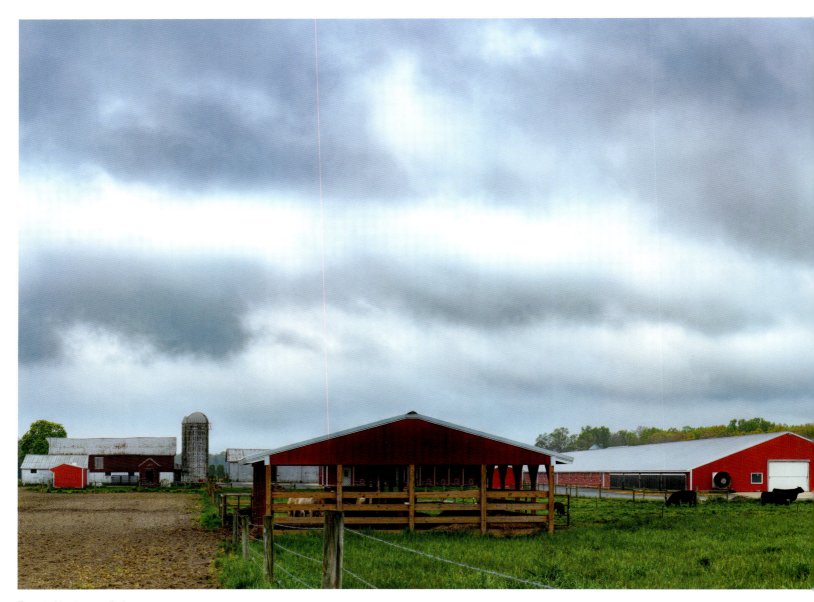

Farm in Harrington, Delaware

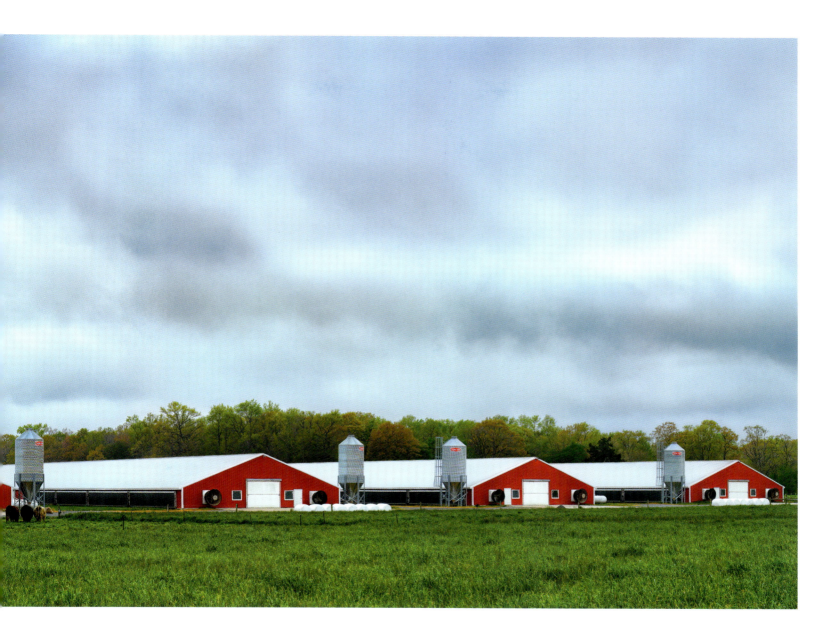

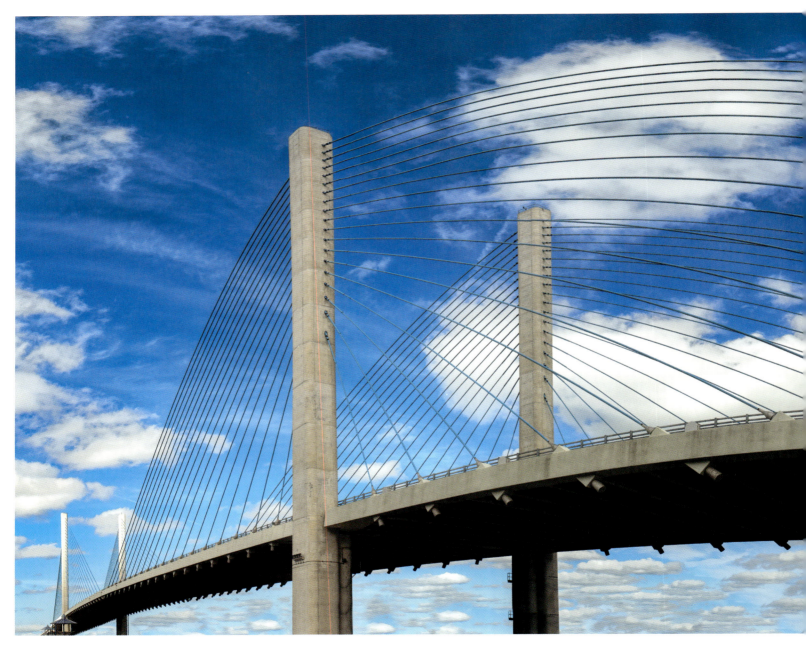

Senator William V. Roth Jr. Bridge, Delaware

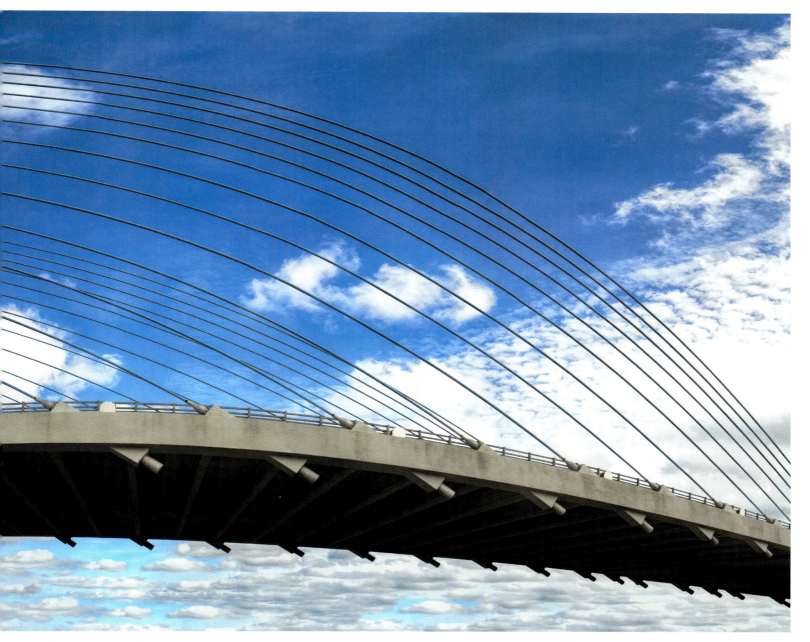

Route 1 spanning the Chesapeake & Delaware Canal

Chincoteague Bay, Maryland

Maryland

When I was composing this photograph, a motorcycle gang pulled up.
Their leader yelled to them to stay off this pier until I was finished. So thoughtful!

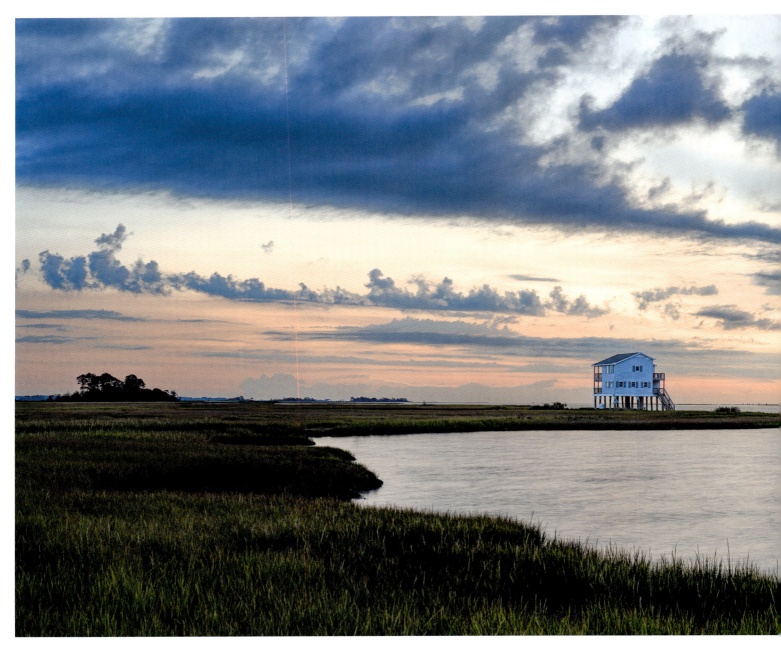

Sunrise at George Island Landing, Maryland

Maryland

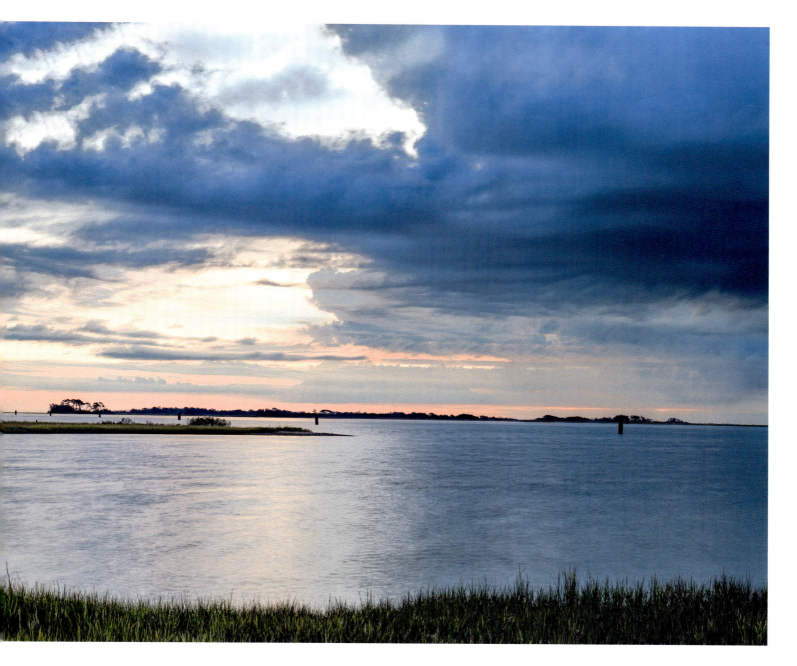

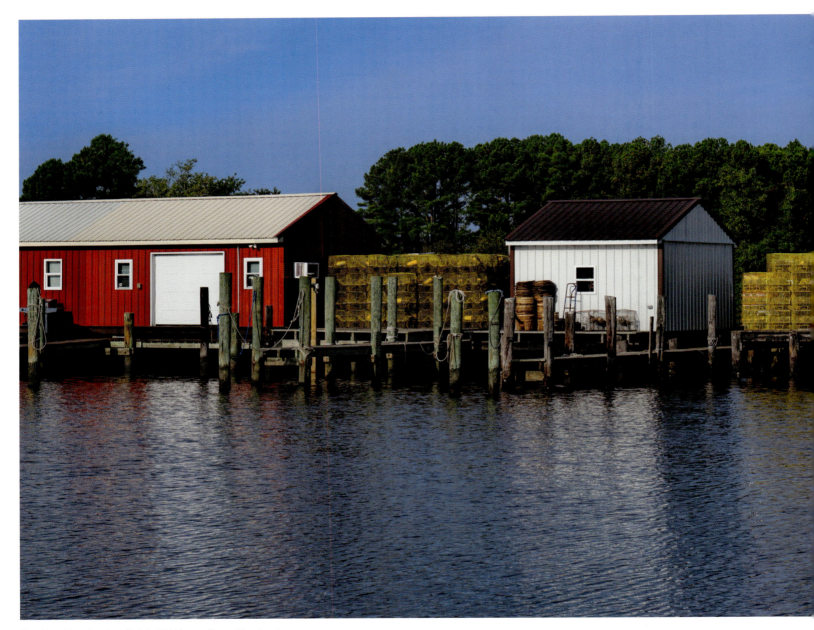
The *Lisa Meg*, Landon Point, Old House Cove, Maryland

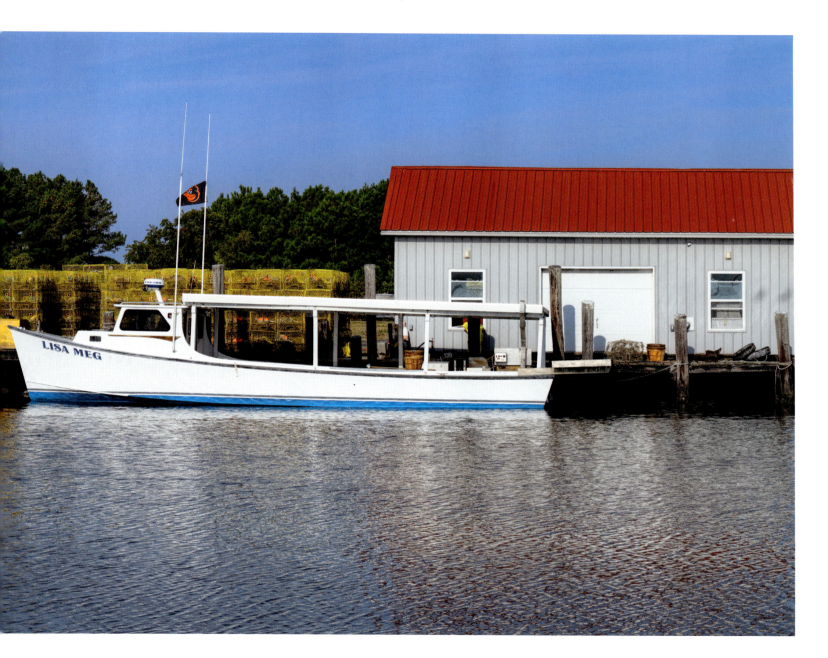

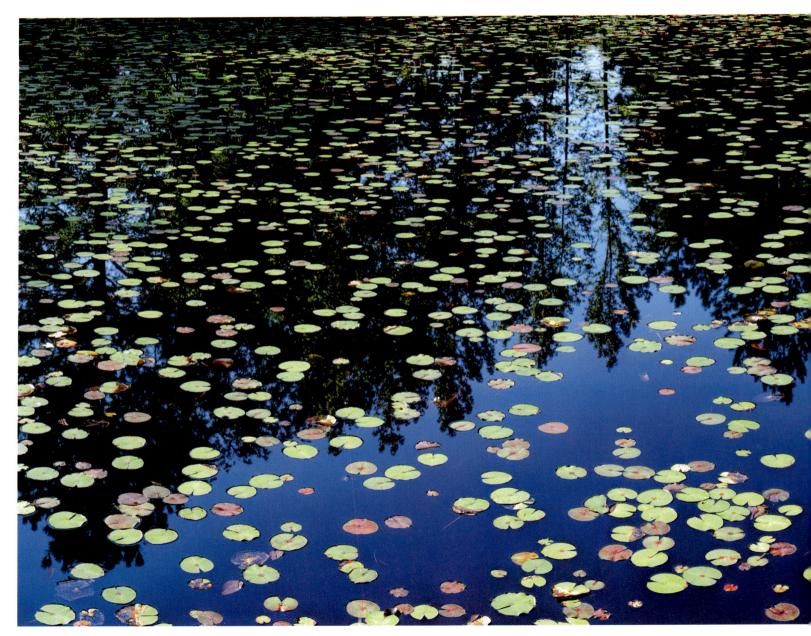

Lily Pond, Mount Hermon Road, Parsonsburg, Maryland

Maryland

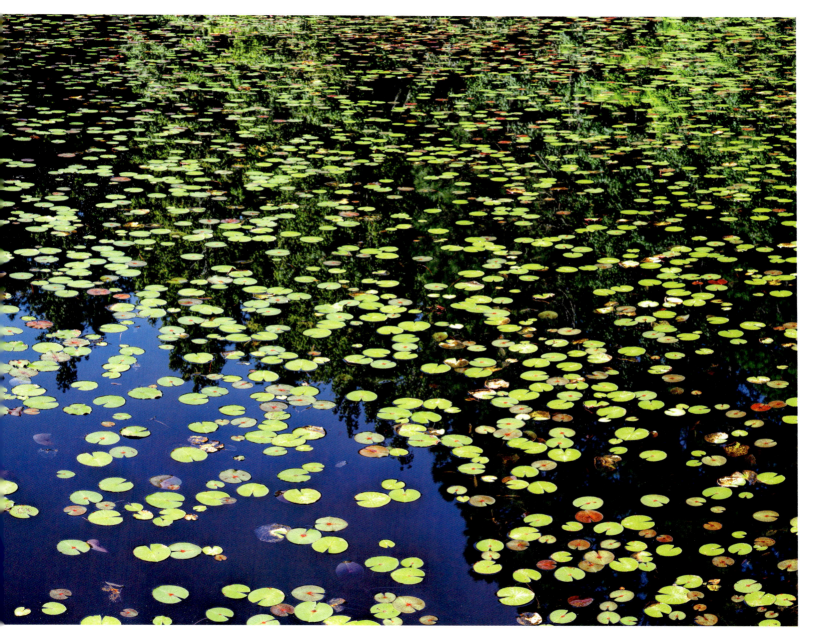

My apologies to the dozens of tiny frogs that jumped in fear as I walked around to find my spot.

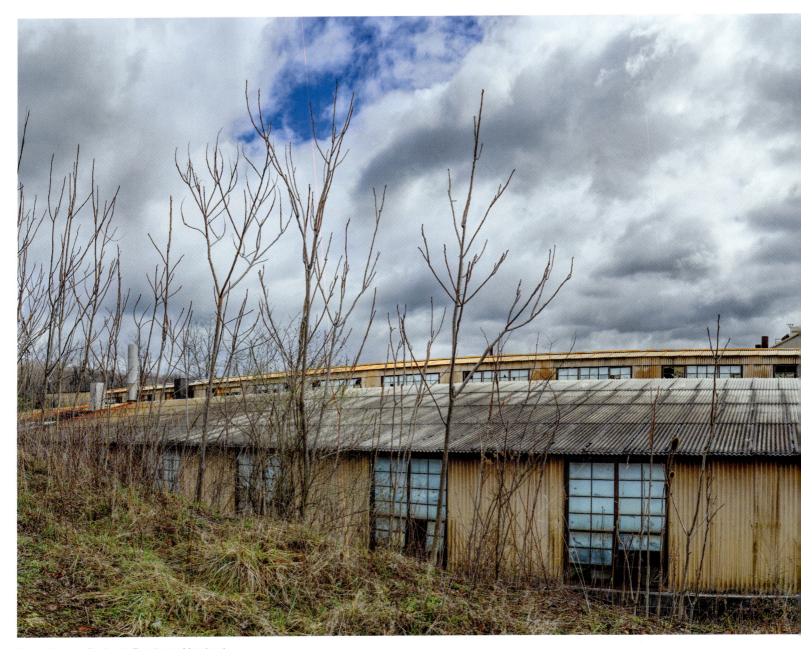

Mount Savage Firebrick, Frostburg, Maryland

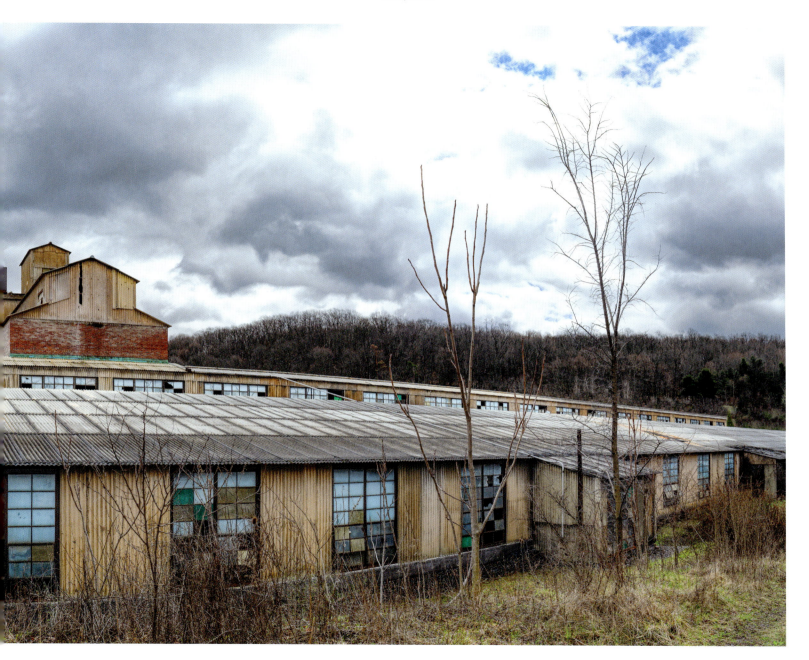

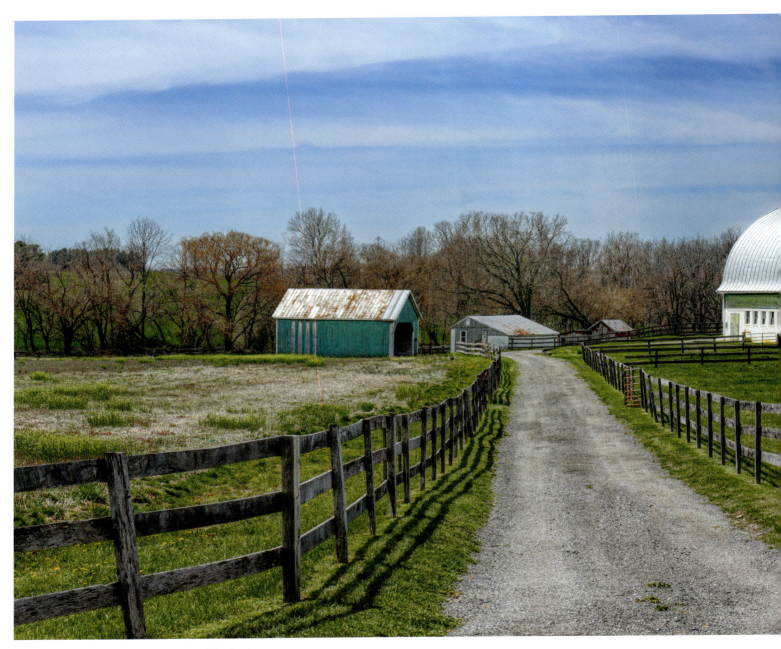

Barn on Old Taneytown Road, Fizzleburg, Maryland

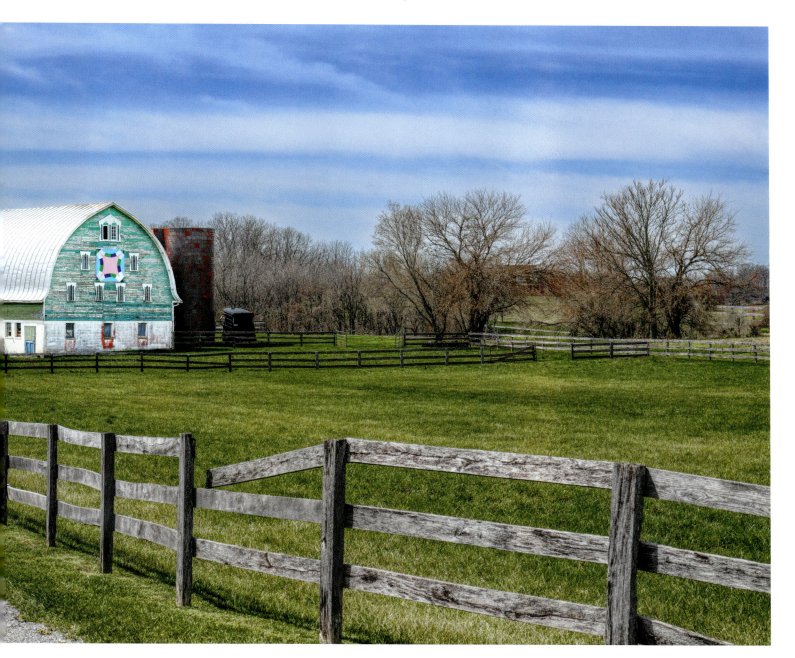

Back Roads of the Mid-Atlantic States

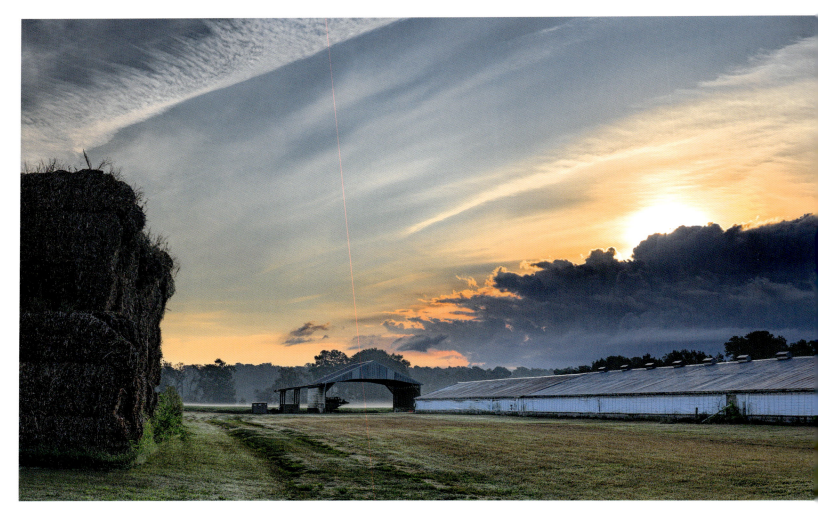

Chicken ranch near Pocomoke City, Maryland

Maryland

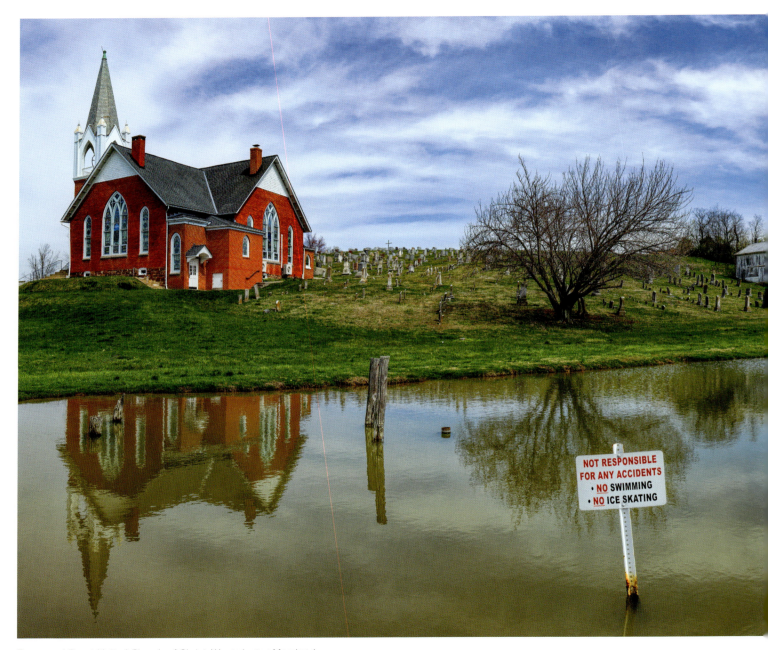

Emmanuel Baust United Church of Christ, Westminster, Maryland

Maryland

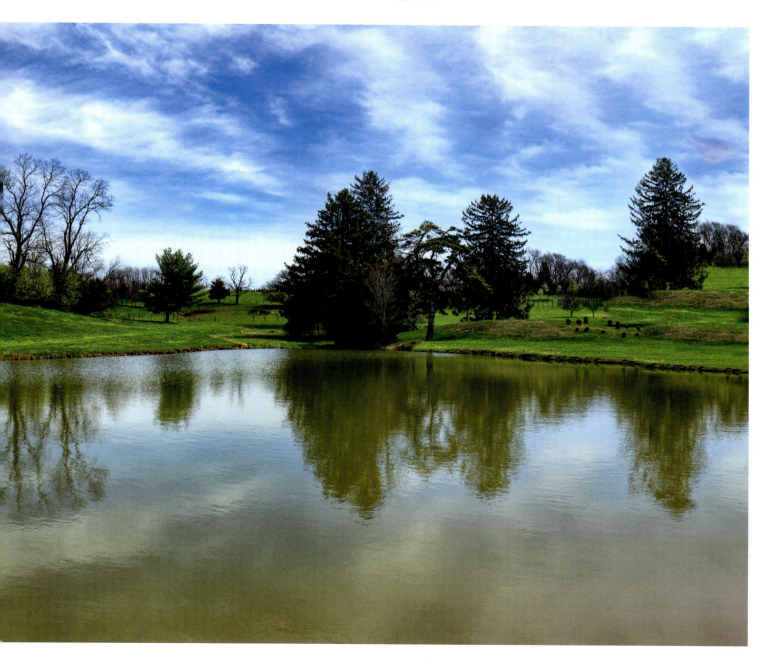

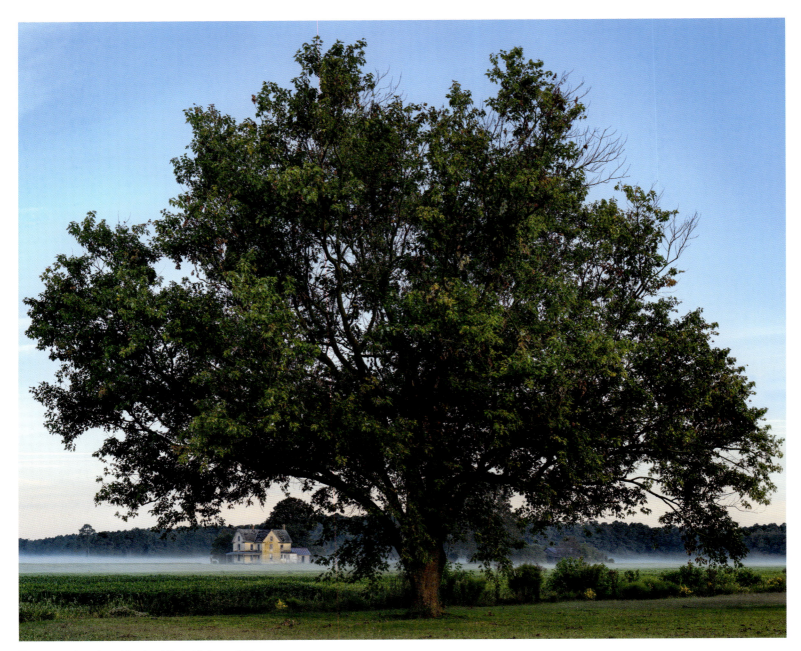

Foggy morning along Maryland State Highway 366

Maryland

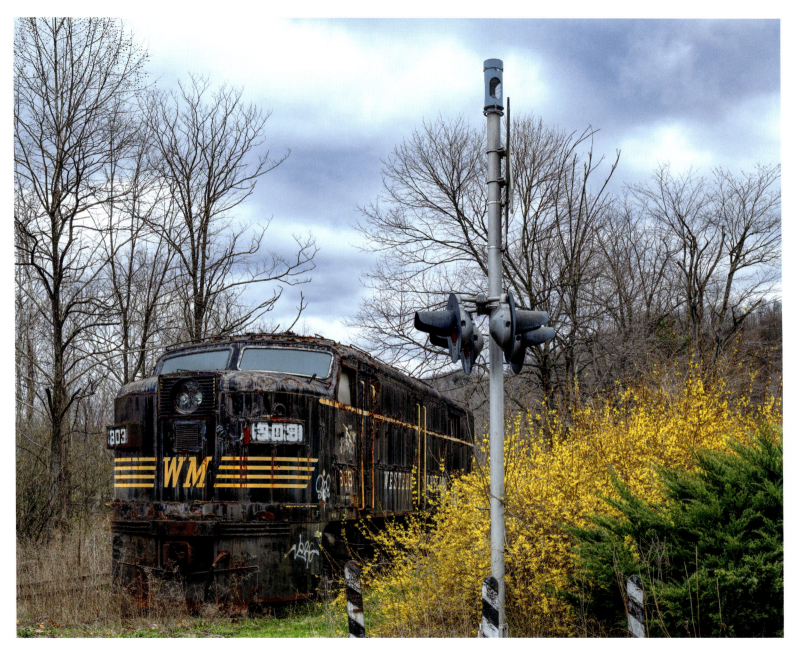

Western Maryland train engine

Tree and fog, Maryland State Highway 366

Maryland

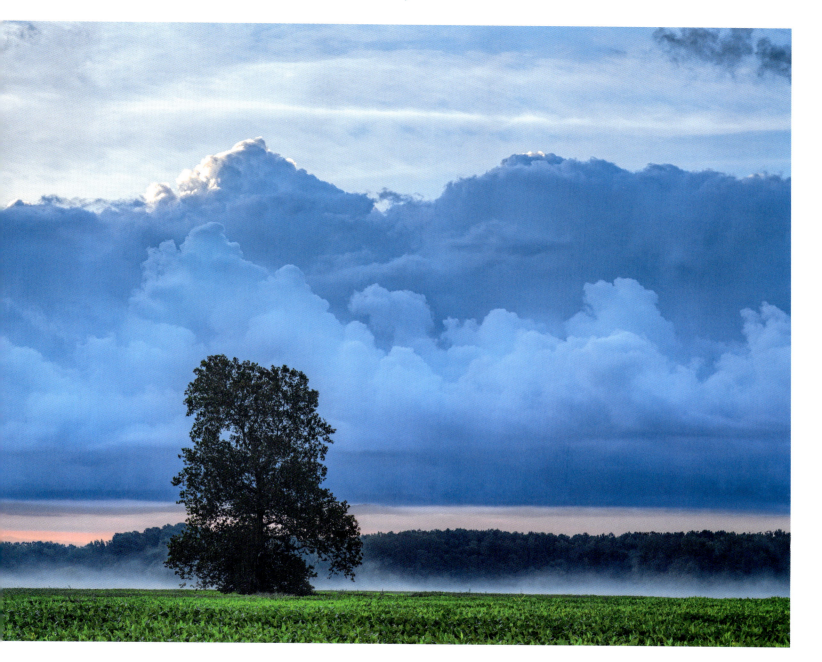

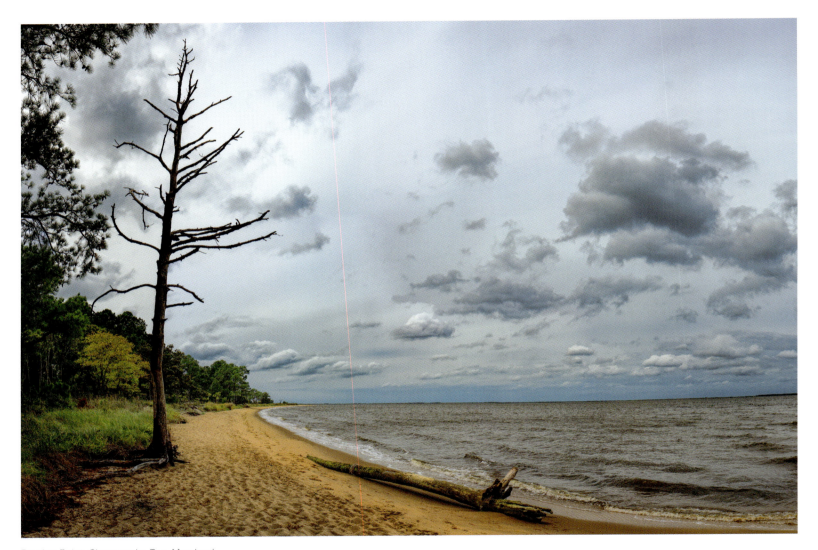

Roaring Point, Chesapeake Bay, Maryland

Maryland

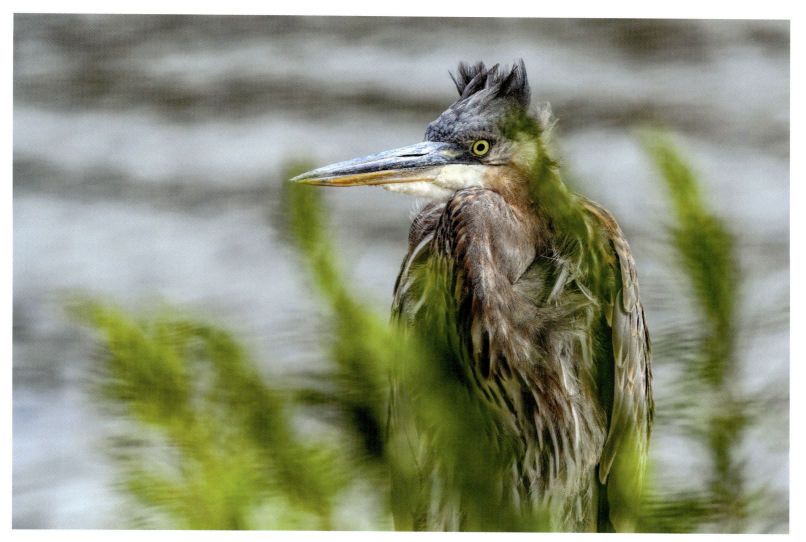

Great blue heron, Blackwater National Wildlife Refuge, Maryland

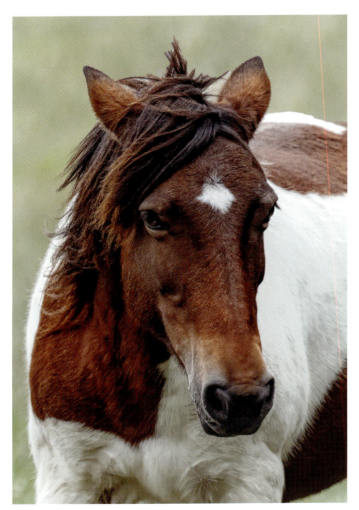 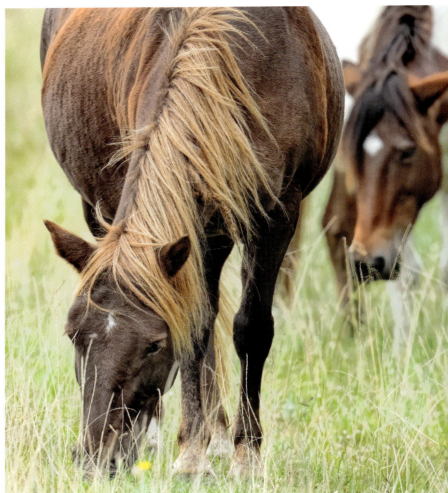

Wild ponies of Assateague Island National Seashore, Maryland

Maryland

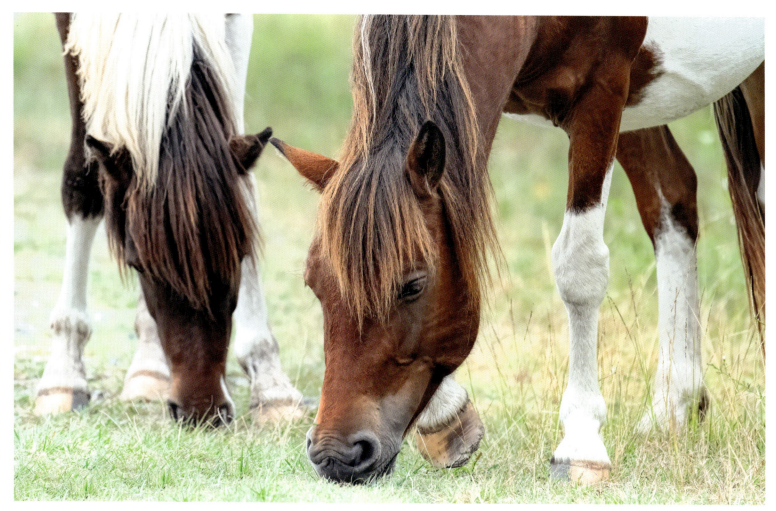

Around 150 wild ponies wander the beaches, inland pine forest, and salt marshes in Virginia; there are another 80 or so in Maryland. They are the descendants of domestic animals who have reverted to a wild state, making them actually "feral."

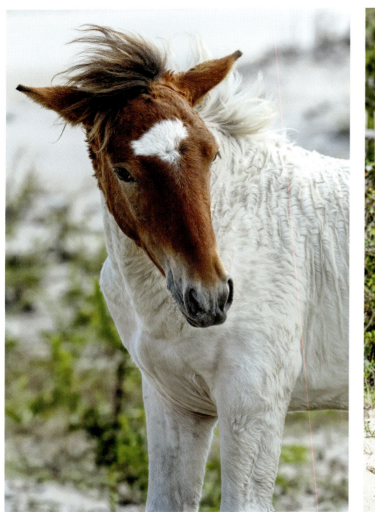
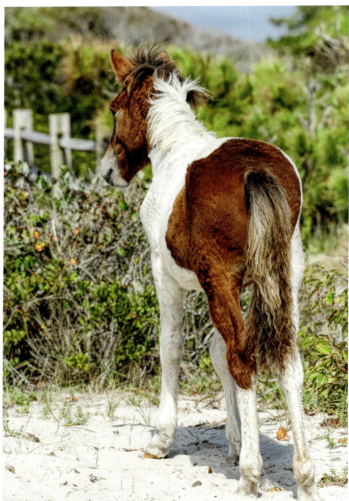

Four-month-old colt with his mother at Assateague Island National Seashore in Maryland

Maryland

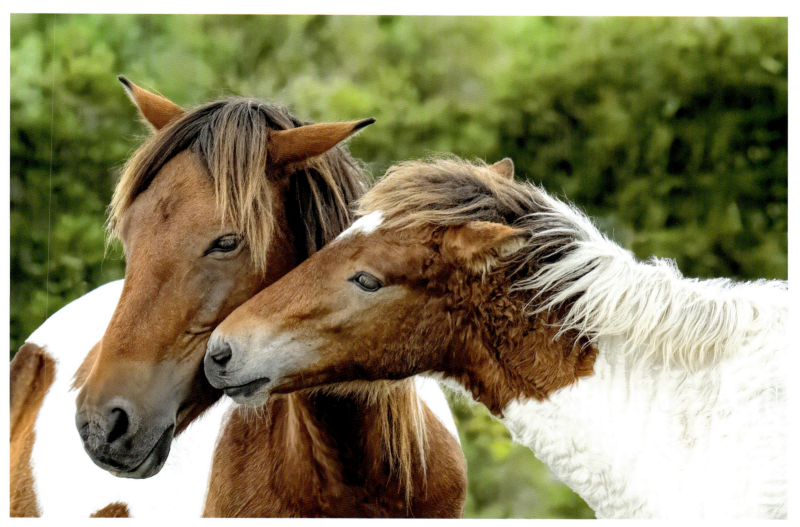

There will be a bidding contest to help pay for the upkeep of this reserve.
The winner will have the honor of naming the baby.

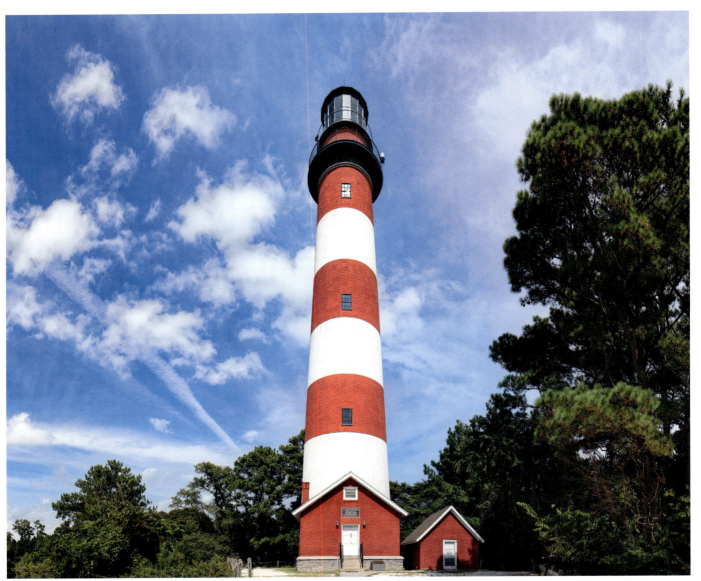

Assateague Lighthouse, Assateague Island, Virginia

Virginia

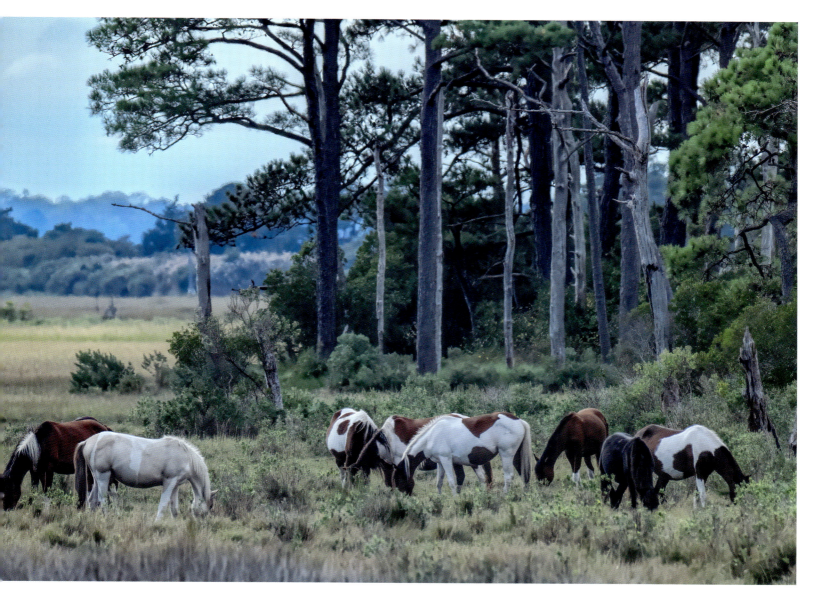

Wild ponies, Assateague Island National Seashore, Virginia

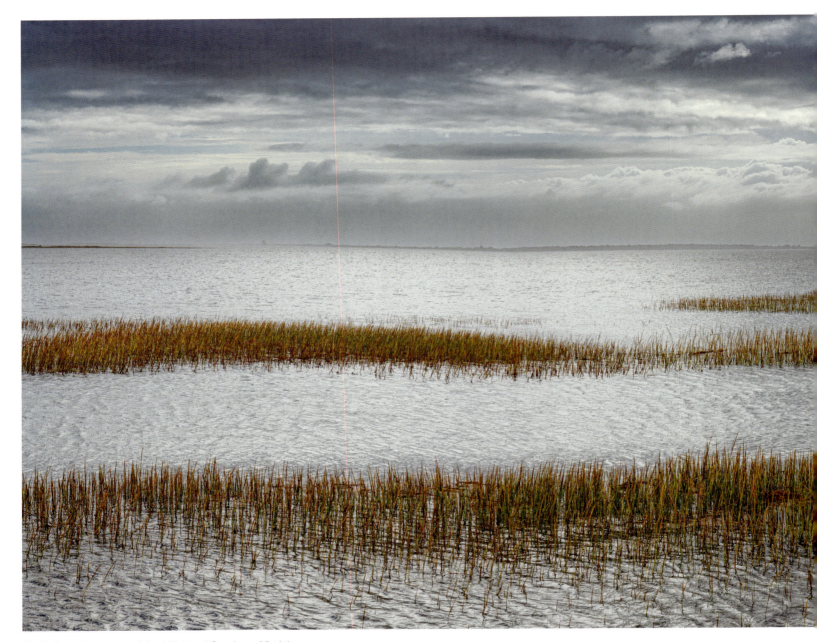

Tom's Cove, Assateague Island National Seashore, Virginia

Virginia

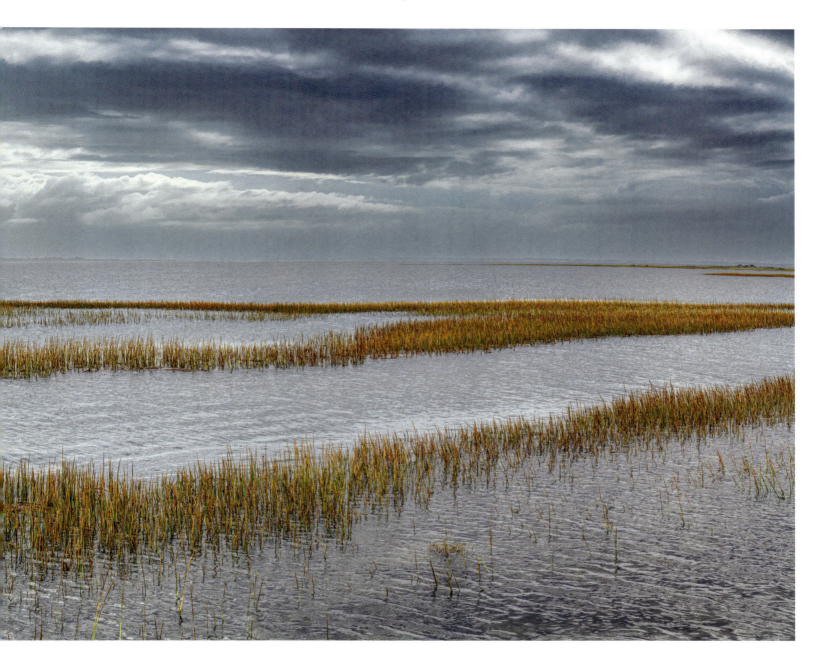

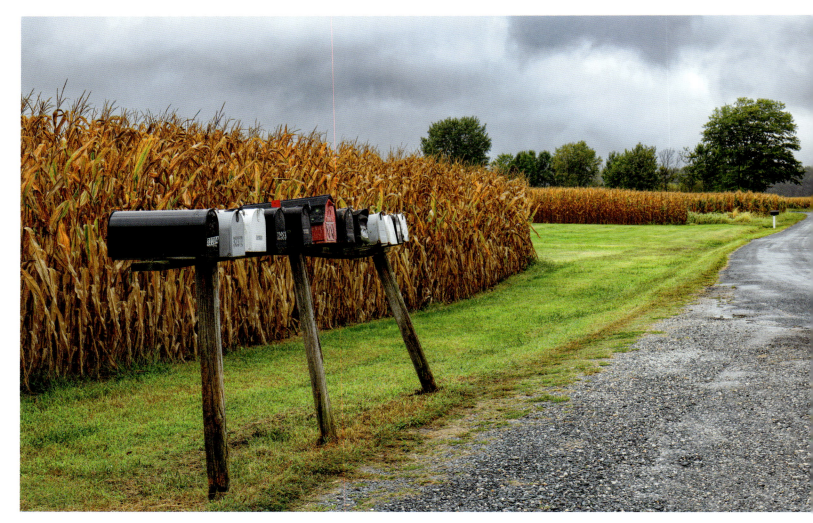
Mailboxes along Coardtown Road, New Church, Virginia

Virginia

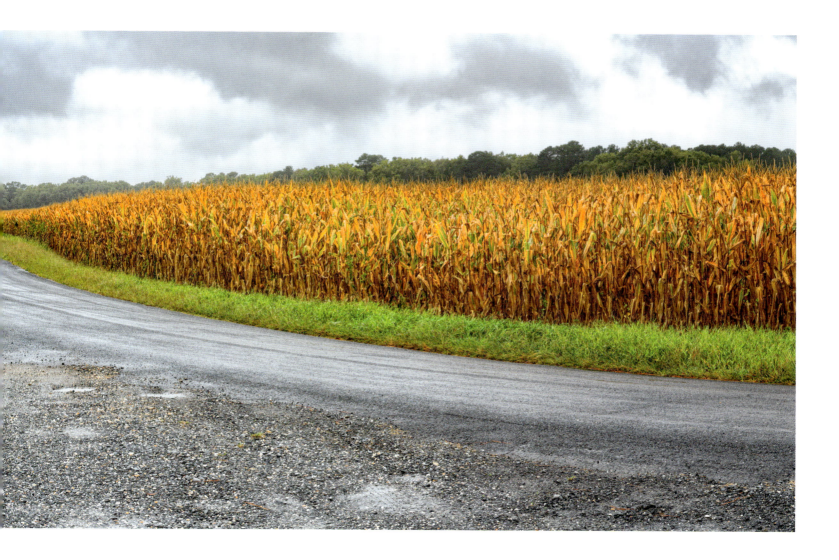

Back Roads of the Mid-Atlantic States

Key West Cottages, Chincoteague Island, Virginia

Virginia

Ten points if you spot the butterfly!

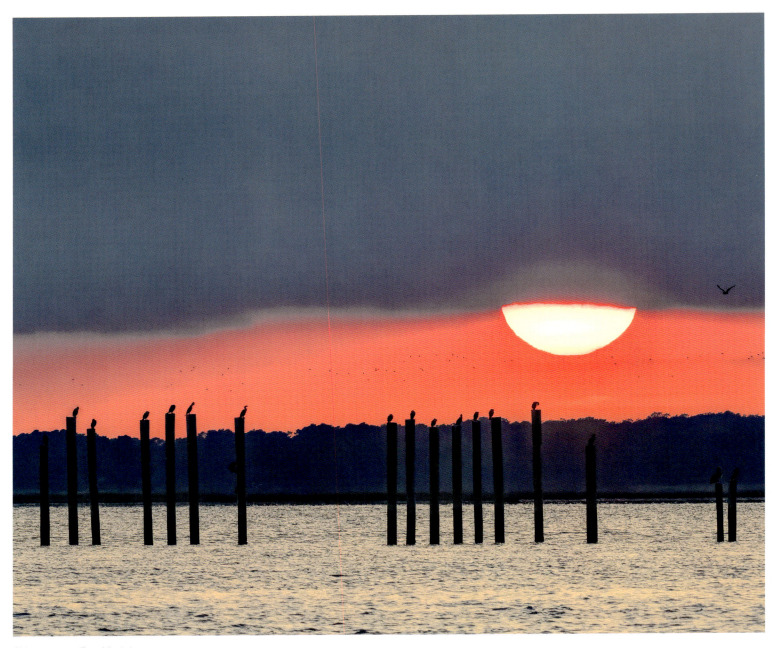

Chincoteague Bay, Virginia

Virginia

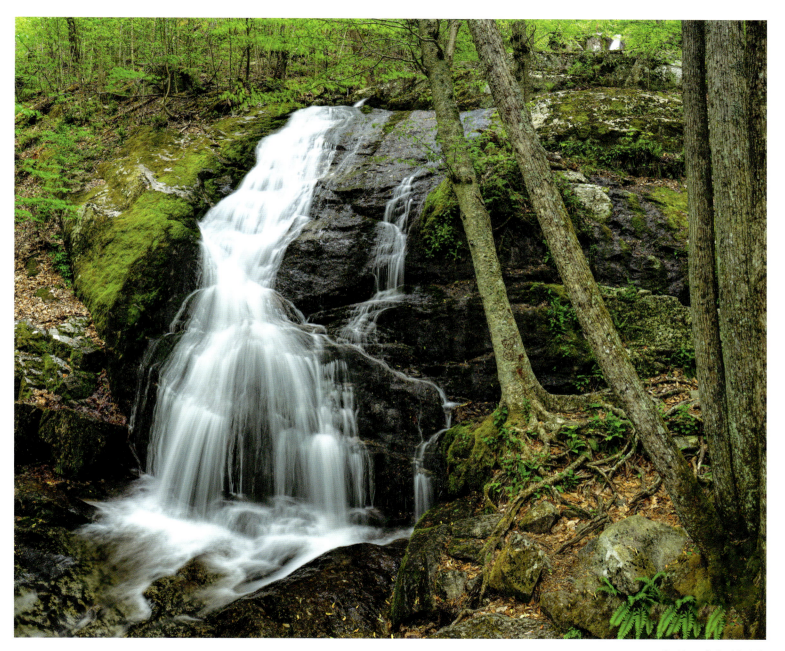

Crabtree Falls, Virginia

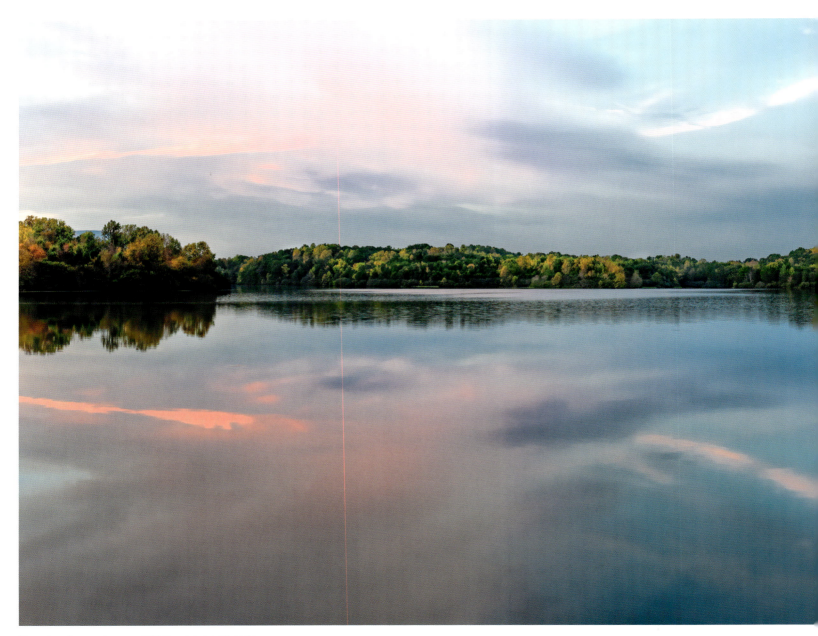
Sunset and moonrise over Mill Creek Lake, Virginia

Virginia

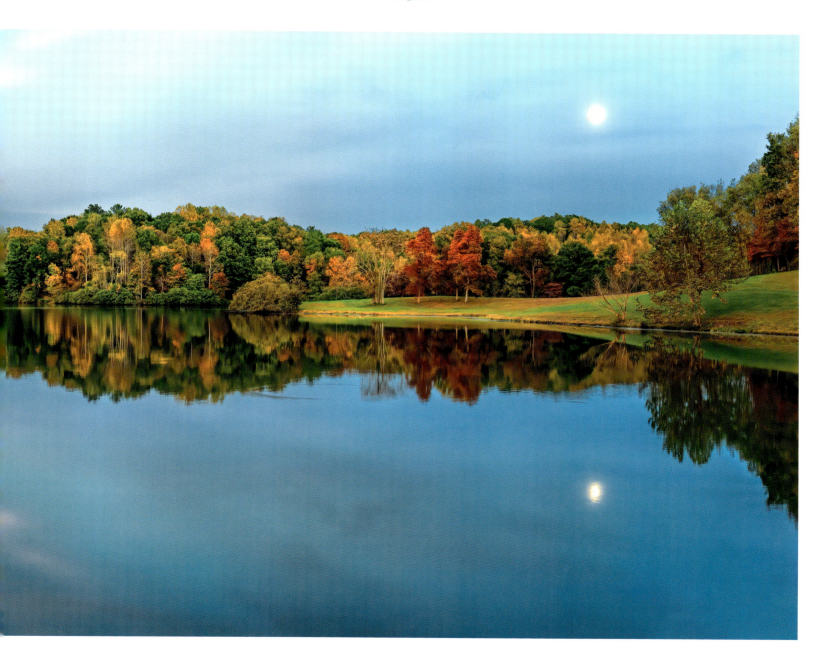

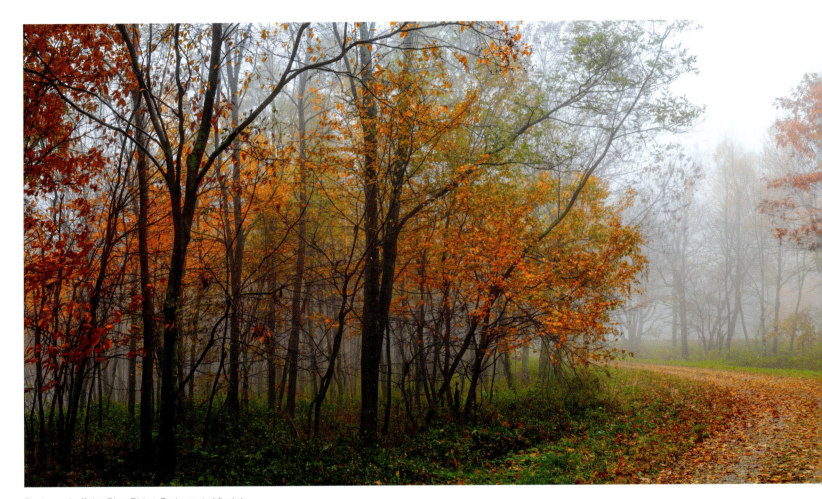

Back road off the Blue Ridge Parkway in Virginia

Virginia

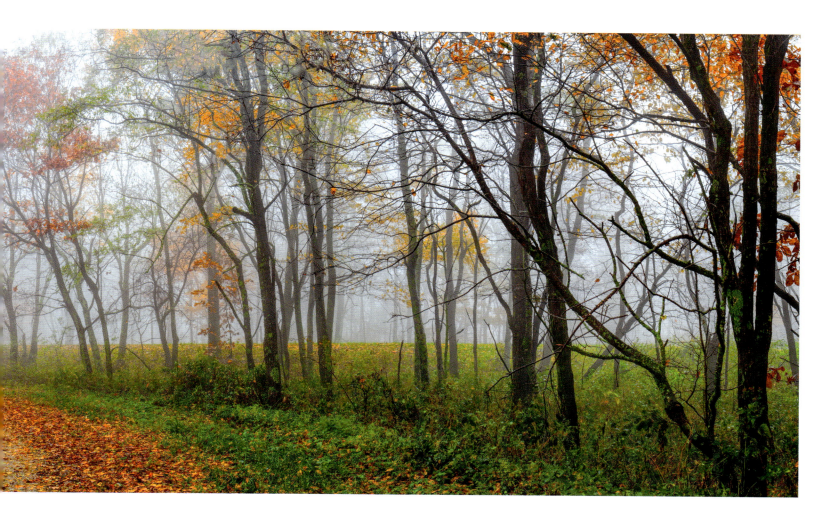

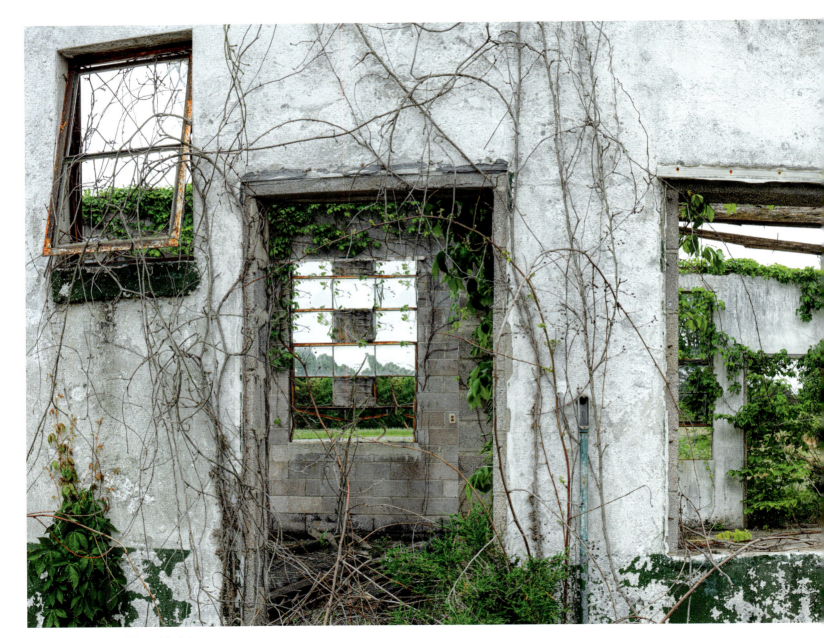

Village Highway, Lynchburg, Virginia

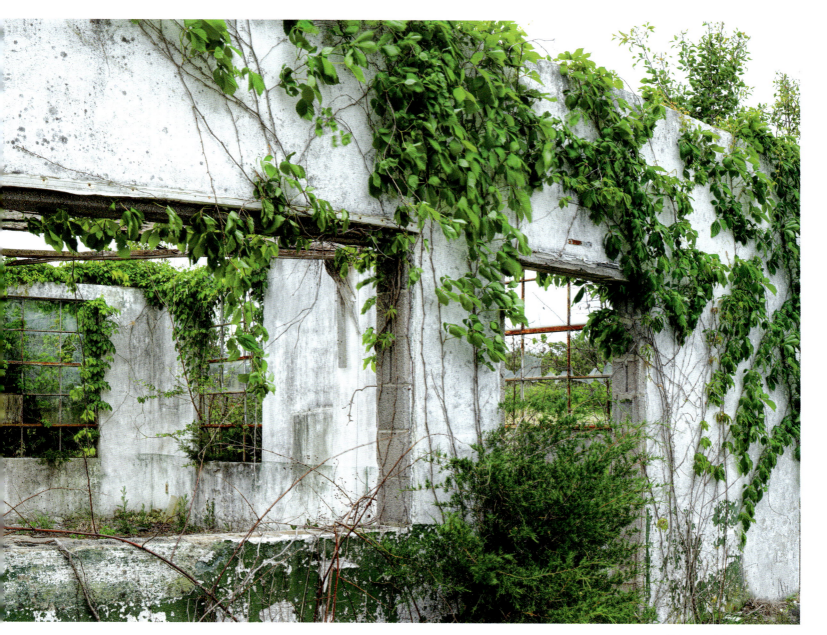

Nature reclaiming civilization

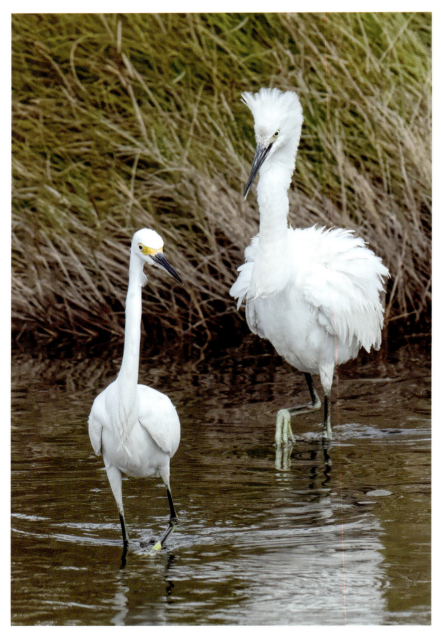

Snowy egrets, Wildlife Loop, Assateague Island, Virginia

Virginia

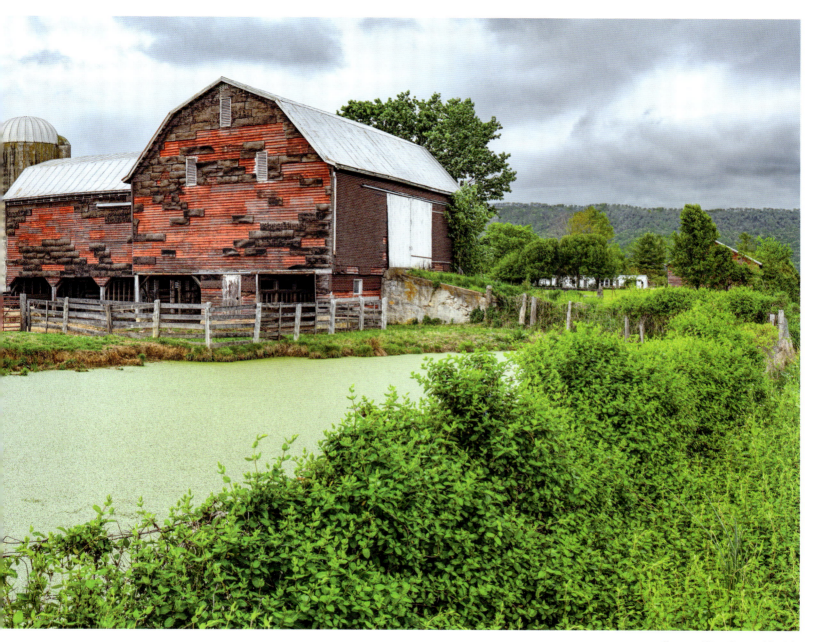

Barn on Kites Corner, Virginia

The Humpback Covered Bridge, Covington, Virginia

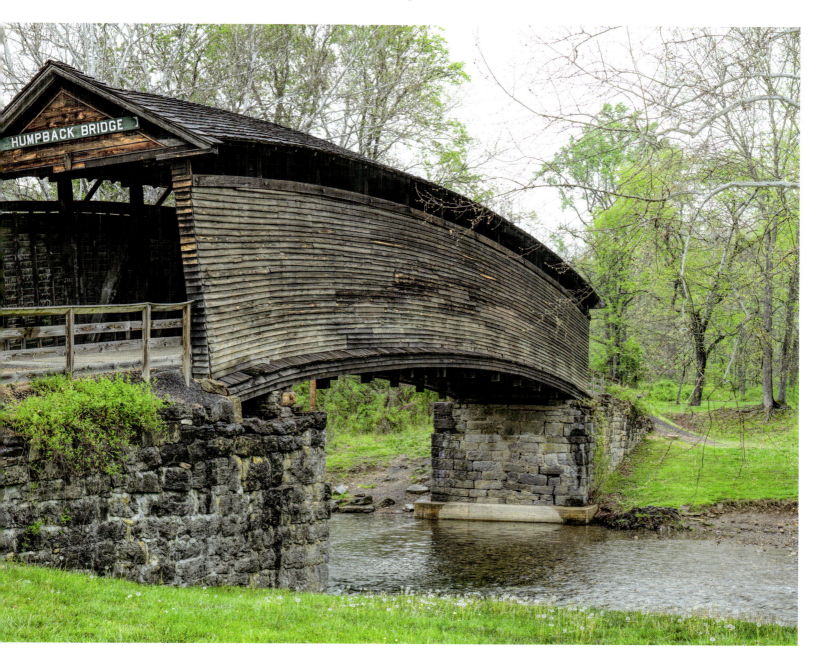

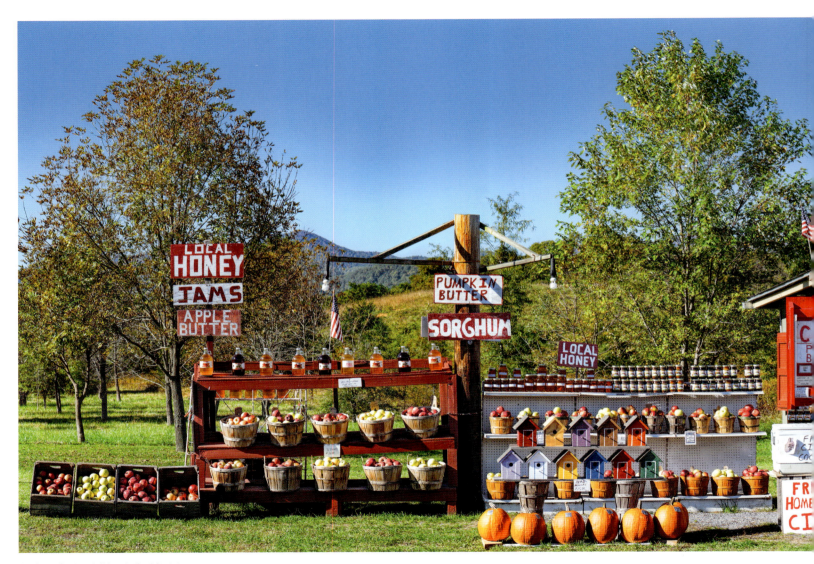

Jenkins Orchard, Woodville, Virginia

Virginia

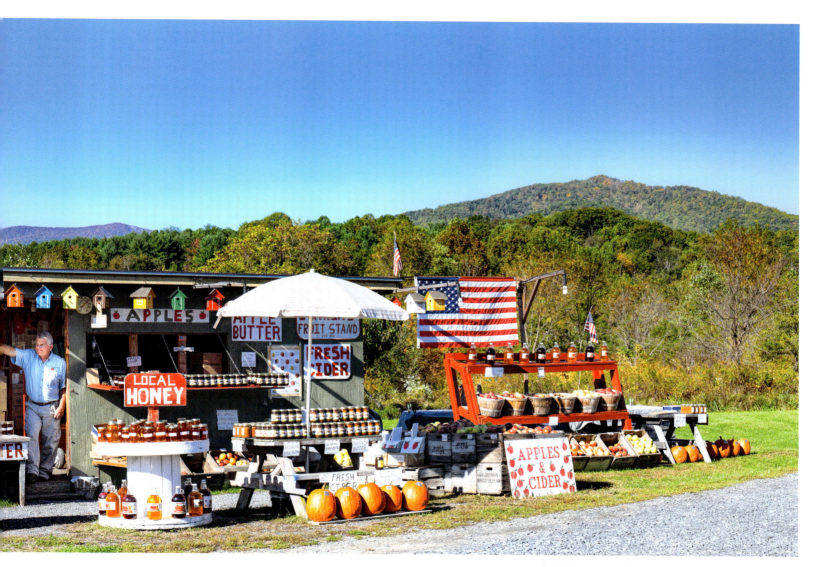

I still have some of that honey. I'm trying to make it last!

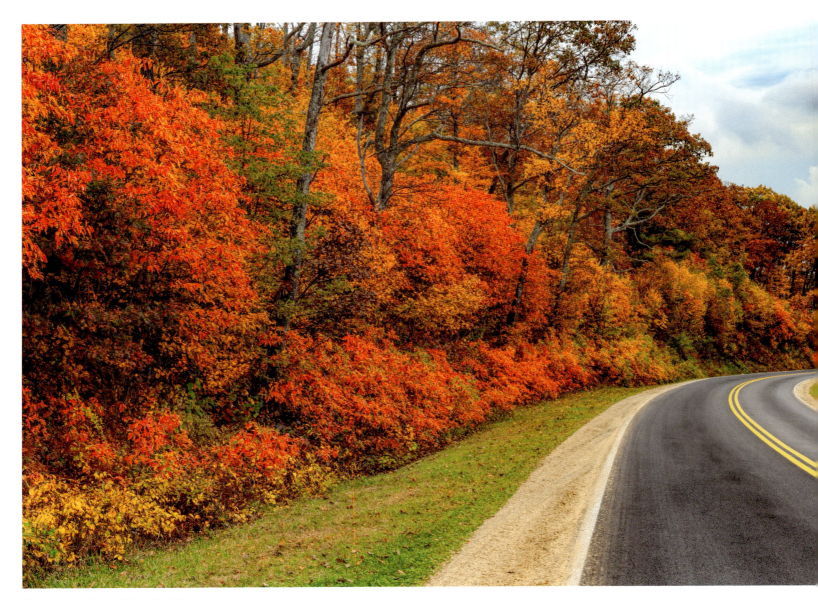

Shenandoah National Park, Virginia

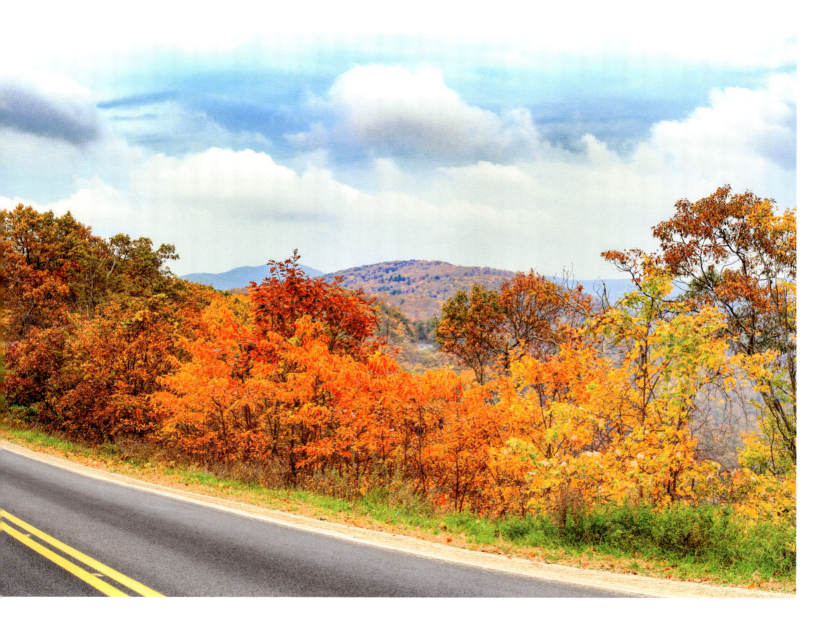

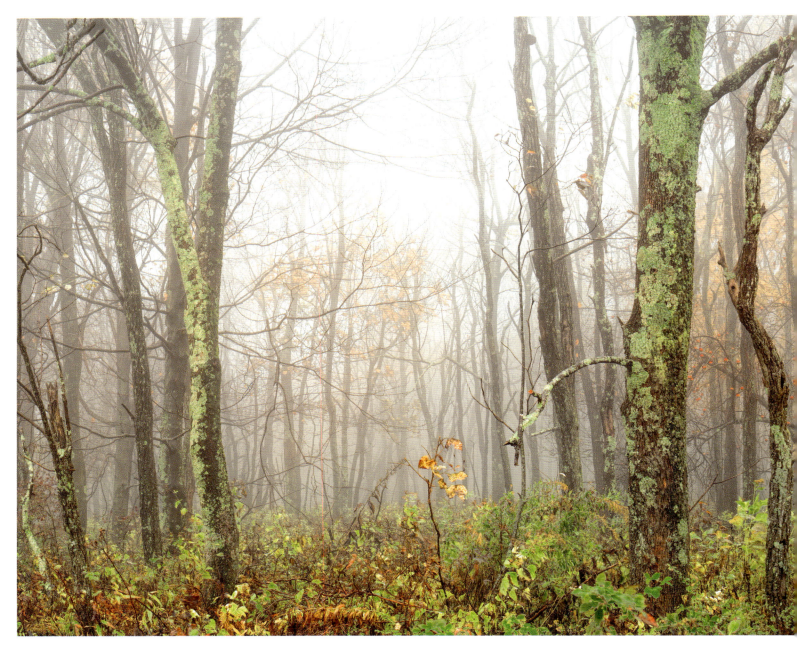

Old apple orchard, Blue Ridge Parkway, Virginia

Virginia

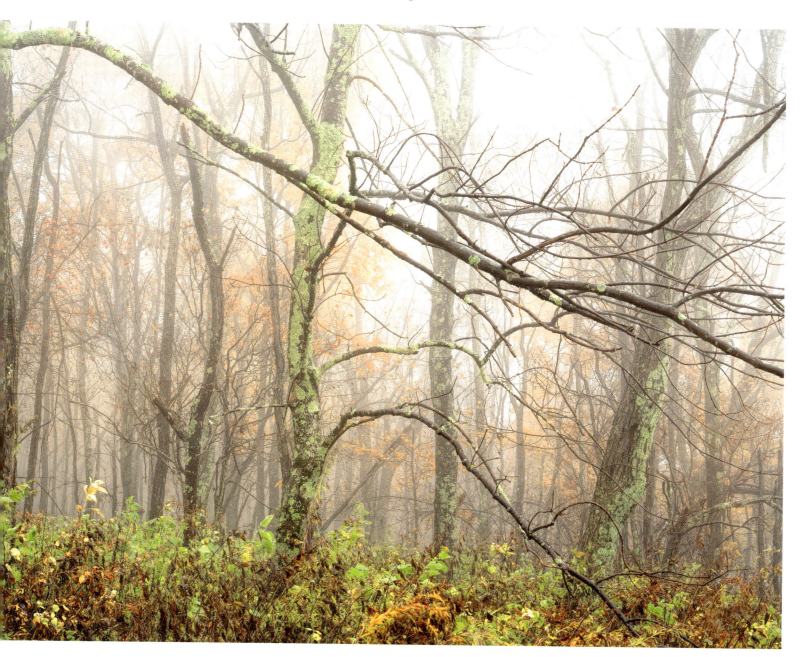

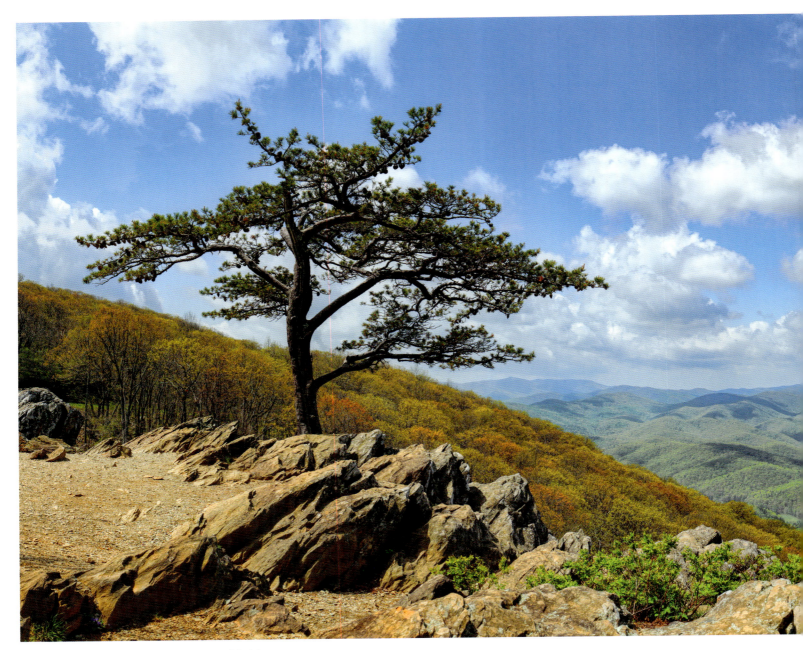

Ravens Roost Overlook, Blue Ridge Parkway, Virginia

Virginia

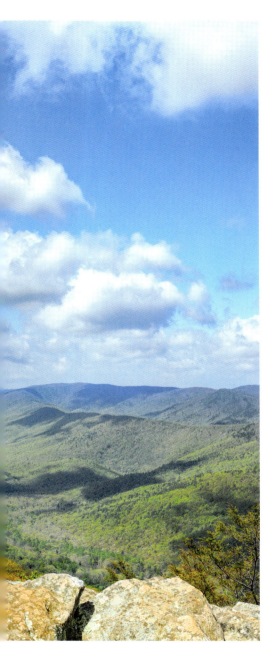
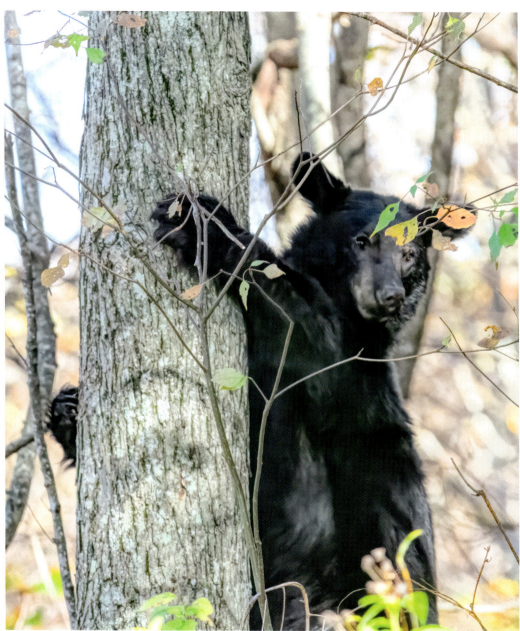

Black bear, Shenandoah National Park, Virginia

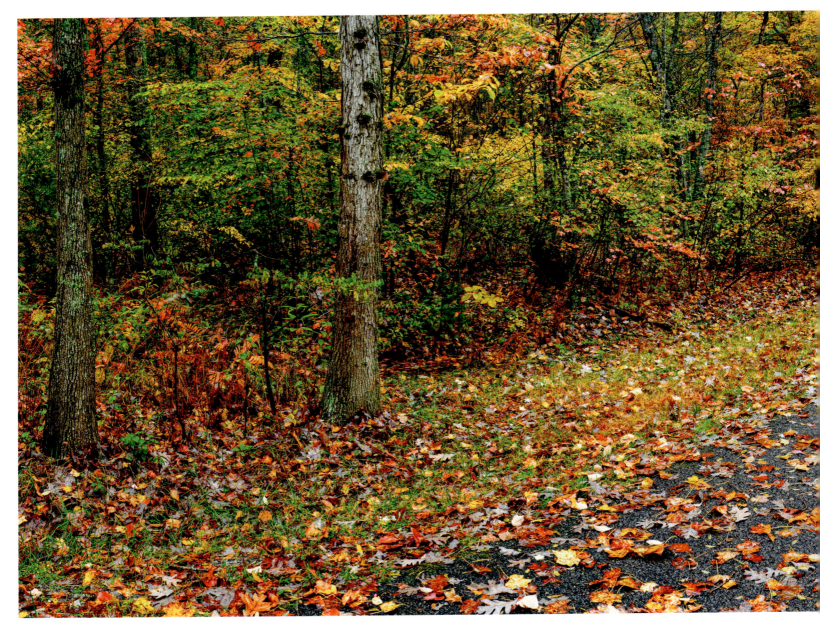

Road to Sherando Lake, Virginia

Virginia

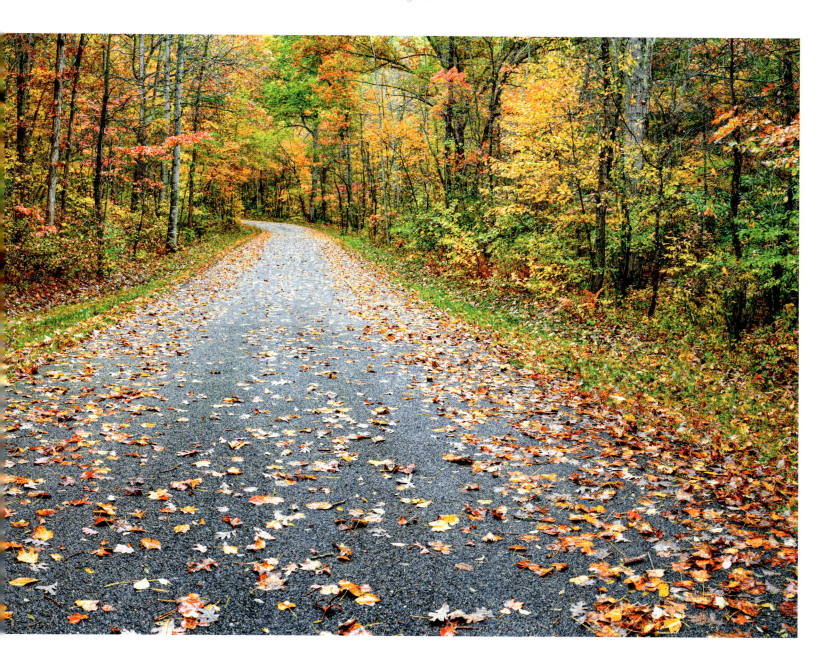

Back Roads of the Mid-Atlantic States

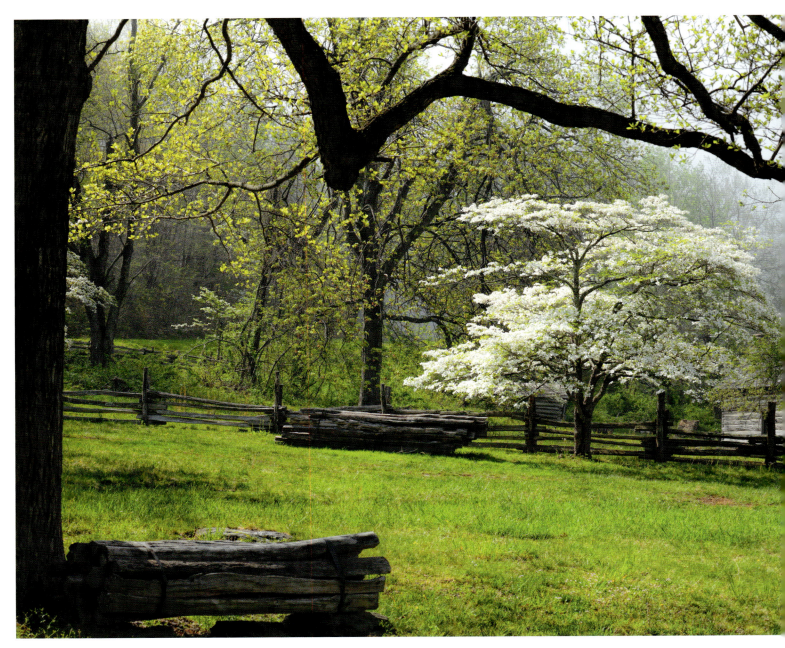

Cabins and dogwoods, Blue Ridge Mountains, Virginia

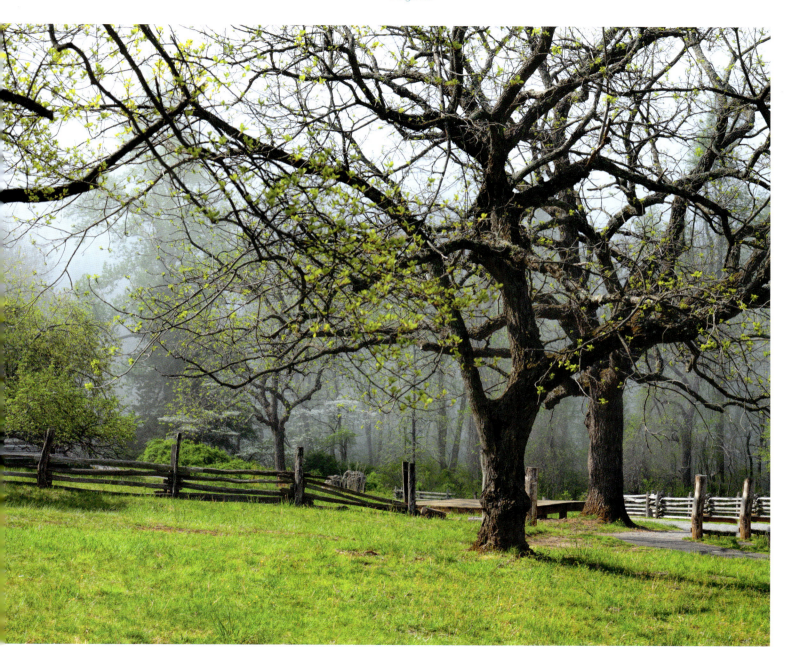

APPENDIX

For all the photographers out there who love to have all the tech information, I have included this appendix. May the geeks like me enjoy!

Image Number	Image Name	Camera	Lens	F/Stop	Shutter Speed	ISO	Pano Image Count	Pano Levels	Native Dimensions in Inches
01	Farm at sunrise	Nikon D700	Nikkor 35 mm f/1.4	f/11	1/25	100	8	1	54x18
02	Sach's Bridge	Nikon D850	Nikkor 50 mm f/1.4	f/11	1/400	64	8	1	48x18
03	Paradise	Nikon D500	Nikkor 200–500 mm f/5.6	f/9.0	1/2500	720	n/a	n/a	24x9
04A	Clearfield Farms barn	Nikon D850	Nikkor 50 mm f/1.4	f/11	1/80	64	12	2	42x42
04B	Chris's Farm gourds	Nikon D850	Nikkor 50 mm f/1.4	f/11	1/80	64	15	3	60x60
05	Lyndon Diner, Lancaster	Nikon D850	Nikkor 50 mm f/1.4	f/13	1.6"	64	6	1	43x18
06	Lindon Diner, York	Nikon D850	Nikkor 50 mm f/1.4	f/11	1/5	64	12	1	70x22
07	Apple orchard	Nikon D700	Nikkor 35 mm f/1.4	f/16	1/200	100	9	1	54x21
08	Walnut Street	Nikon D850	Zeiss 135 mm f/2.0	f/11	1/30	64	6	1	53x21
09	Hall's Mill Bridge	Nikon D850	Nikkor 50 mm f/1.4	f/11	1/250	64	12	1	62x22
10	Fendrick Library	Nikon D850	Nikkor 50 mm f/1.4	f/11	1/200	64	10	1	61x23
11	Lancaster County farming	Nikon D500	Nikkor 200–500 mm f/5.6	f/9.0	1/2500	1100	n/a	n/a	24x10
12	Lincoln Motor Court	Nikon D850	Nikkor 50 mm f/1.4	f/13	1/125	64	14	1	71x22
13A	Fruit farm crates	Nikon D300	Nikkor 50 mm f/1.4	f/13	1/8	200	n/a	n/a	16x24
13B	Gourds and barn	Nikon D850	Nikkor 85 mm f/1.8	f/10	1/160	64	24	2	66x29
14	Dutch Wonderland	Nikon D850	Nikkor 50 mm f/1.4	f/11	1/100	64	8	1	55x22
15	Fisher's Produce	Nikon D850	Nikkor 50 mm f/1.4	f/11	1/250	64	13	1	53x21
16A	Sugar Mill Farms	Nikon D850	Nikkor 85 mm f/1.8	f/11	1/60	64	16	2	57x37
16B	Old mill	Nikon D850	Nikkor 50 mm f/1.4	f/14	1/40	64	16	2	59x42
17	Green barn	Nikon D750	Nikkor 85 mm f/1.8	f/10	1/50	100	8	1	40x15
18	Lake Huntington	Nikon D850	Zeiss 135 mm f/2.0	f/9.0	1/160	64	7	1	59x22
19	Washday	Nikon D750	Nikkor 85 mm f/1.8	f/13	1/60	100	7	1	48x16
20	Cascade Lakes	Nikon D850	Nikkor 85 mm f/1.8	f/16	1/8	64	8	1	63x23
21	Villa Vosilla	Nikon D750	Nikkor 35 mm f/1.4	f/11	1/320	100	8	1	66x26
22A	Loon Lake boats	Nikon D850	Nikkor 85 mm f/1.8	f/14	1/15	64	16	2	49x30
22B	Loon Lake	Nikon D850	Zeiss 135 mm f/2.0	f/11	1/8	64	16	2	48x30
23	Great Sacandaga Lake	Nikon D850	Zeiss 135 mm f/2.0	f/10	1/250	160	7	1	60x20
24	Hudson River	Nikon D850	Nikkor 50 mm f/1.4	f/11	1/225	64	20	2	66x25
25	Farmer's Daughter Ice Cream	Nikon D750	Nikkor 85 mm f/1.8	f/11	1/160	100	24	2	70x25
26	Sacandaga Lake	Nikon D850	Nikkor 50 mm f/1.4	f/11	1/60	64	8	1	48x19

27	The Ember Cabins	Nikon D850	Nikkor 85 mm f/1.8	f/10	1/40	64	20	2	95x38
28	Pond and meadow	Nikon D850	Nikkor 50 mm f/1.4	f/11	1/250	64	24	2	74x35
29A	Stone Arch Bridge	Nikon D850	Nikkor 85 mm f/1.8	f/14	1/50	64	14	2	48x30
29B	Delaware River	Nikon D850	Nikkor 50 mm f/1.4	f/11	6"	64	18	2	70x45
30	Wawayanda Lake	Nikon D850	Nikkor 85 mm f/1.8	f/11	1/250	64	9	1	62x22
31	Pine trees and huckleberry	Nikon D850	Nikkor 85 mm f/1.8	f/16	1/30	64	8	1	58x22
32	Pumpkin festival	Nikon D850	Nikkor 85 mm F1.8	f/9.0	1/160	64	26	2	82x30
33	West Cape May	Nikon D850	Nikkor 50 mm f/1.4	f/14	1/320	200	22	2	79x31
34	Dividing Creek Boat Rentals	Nikon D850	Nikkor 50 mm f/1.4	f/11	1/200	64	8	1	43x17
35	Lentini Farms	Nikon D850	Nikkor 50 mm f/1.4	f/9.0	1/15	64	8	1	50x21
36	Trees on Schooley's Mountain Road	Nikon D850	Nikkor 50 mm f/1.4	f/14	1/100	64	11	1	43x18
37	Kohr Ice Cream	Nikon D850	Nikkor 85 mm f/1.8	f/9.0	1/200	64	7	1	48x16
38	Village of Crystal Springs	Nikon D850	Zeiss 135 mm f/2.0	f/9.0	1/50	64	7	2	51x21
39A	Buddy and Ryleigh	Nikon D850	Nikkor 50 mm f/1.4	f/11	1/250	64	7	1	44x46
39B	Newfoundland Station	Nikon D850	Nikkor 50 mm f/1.4	f/11	1/50	64	16	2	50x38
40	Wetlands, Golden Shores	Nikon D850	Nikkor 50 mm f/1.4	f/11	1/200	64	9	1	53x22
41	Cardinal Road houses	Nikon D850	Nikkor 50 mm f/1.4	f/11	1/250	64	8	1	50x19
42	East Point Lighthouse	Nikon D850	Nikkor 50 mm f/1.4	f/11	1/250	64	22	2	77x33
43	Carnival Cove	Nikon D850	Nikkor 50 mm f/1.4	f/10	1/250	64	12	1	84x32
44	So Sweet Candy Store	Nikon D850	Nikkor 50 mm f/1.4	f/14	1/15	64	14	1	80x22
45A	Duplex on 3rd and 92nd	Nikon D810	Nikkor 85 mm f/1.8	f/10	1/320	64	6	1	39x22
45B	Absecon Lighthouse	Nikon D850	Nikkor 50 mm f/1.4	f/13	1/160	64	12	2	36x46
46A	Egret	Nikon D500	Nikkor 200–500 mm f/5.6	F7.1	1/6400	1000	n/a	n/a	20x30
46B	White-tailed deer	Nikon D500	Nikkor 200–500 mm f/5.6	f/6.3	1/4000	4500	n/a	n/a	24x13
47A	Hopkins Farm Creamery	Nikon D850	Nikkor 50 mm f/1.4	f/13	1/200	64	10	2	32x40
47B	Harbor of Refuge Light	Nikon D850	Nikkor -50 mm f/1.4	f/11	1/250	64	6	1	52x32
48	Cape Henlopen State Park	Nikon D850	Nikkor -50 mm f/1.4	f/11	1/2000	800	9	1	60x30
49A	Batwood Greens	Nikon D850	Nikkor -50 mm f/1.4	f/11	1/80	64	20	2	59x33
49B	Fenwick Island Lighthouse	Nikon D850	Nikkor -50 mm f/1.4	f/13	1/160	64	12	2	31x37
50	Rust's Sub and Sandwiches	Nikon D850	Nikkor -50 mm f/1.4	f/11	1/80	64	10	1	50x22
51	1940s chicken ranch	Nikon D850	Nikkor -50 mm f/1.4	f/13	1/200	64	7	1	47x19
52	Pigeon ranch	Nikon D850	Nikkor -50 mm f/1.4	f/11	1/160	64	8	1	52x20
53A	European starlings	Nikon D500	Nikkor 200–500 mm f/5.6	f/6.3	1/4000	500	n/a	n/a	32x22
53B	Carey's Camp	Nikon D850	Nikkor -50 mm f/1.4	f/13	1/160	64	18	2	53x39
54	Farm in Harrington	Nikon D850	Nikkor 85 mm f/1.8	f/14	1/25	64	11	1	70x22
55	Senator William V. Roth Jr. Bridge	Nikon D750	Nikkor 35 mm f/1.4	f/11	1/160	100	20	2	84x36
56	Chincoteague Bay	Nikon D850	Nikkor 50 mm f/1.4	f/14	1/100	64	9	1	49x20
57	George Island Landing	Nikon D850	Nikkor 50 mm f/1.4	f/11	1/40	64	7	1	40x15
58	*Lisa Meg*, Landon Point	Nikon D850	Nikkor 85 mm f/1.8	f/9.0	1/500	64	16	2	48x25
59	Lily pond, Mt. Hermon Rd.	Nikon D850	Nikkor 85 mm f/1.8	f/14	1/25	64	9	1	63x24

#	Title	Camera	Lens	Aperture	Shutter	ISO	Temp	EV	Size
60	Mt. Savage Firebrick	Nikon D850	Nikkor 50 mm f/1.4	f/13	1/160	100	26	2	83x33
61	Barn on Old Taneytown Rd	Nikon D850	Nikkor 85 mm f/1.8	f/13	1/200	64	10	1	48x20
62	Chicken ranch, Pocomoke City	Nikon D850	Nikkor 85 mm f/1.8	f/11	1/160	64	10	1	71x22
63	Emmanuel Baust United Church	Nikon D850	Nikkor 50 mm f/1.4	f/11	1/200	64	20	2	74x35
64A	Big tree, little house	Nikon D850	Nikkor 85 mm f/1.8	f/11	1/20	64	12	2	34x28
64B	Western Maryland train	Nikon D850	Nikkor 50 mm f/1.4	f/10	1/160	64	6	1	28x23
65	Tree and fog	Nikon D850	Nikkor 85 mm f/1.8	f/14	1/40	64	7	1	42x18
66A	Roaring Point Beach	Nikon D850	Nikkor 50 mm f/1.4	f/13	1/160	64	16	2	52x36
66B	Great blue heron	Nikon D500	Nikkor 200–500 mm f/5.6	f/6.3	1/4000	560	n/a	n/a	30x20
67A	Wild horse, Assateague Island	Nikon D500	Nikkor 200–500 mm f/5.6	f/6.3	1/2000	1600	n/a	n/a	20x30
67B	Wild horses	Nikon D500	Nikkor 200–500 mm f/5.6	f/6.3	1/1600	2800	n/a	n/a	24x23
67C	Wild horses 2	Nikon D500	Nikkor 200–500 mm f/5.6	f/6.3	1/3200	4800	n/a	n/a	30x20
68A	Four-month-old colt	Nikon D500	Nikkor 200–500 mm f/5.6	f/7.1	1/4000	3600	n/a	n/a	20x30
68B	Colt standing	Nikon D500	Nikkor 200–500 mm f/5.6	f/8	1/4000	1100	n/a	n/a	20x30
68C	Colt and mother	Nikon D500	Nikkor 200–500 mm f/5.6	f/7.1	1/4000	5600	n/a	n/a	30x20
69A	Assateague Lighthouse	Nikon D850	Nikkor 50 mm f/1.4	f/13	1/160	64	18	2	59x50
69B	Horses on Assateague Island	Nikon D500	Nikkor 200–500 mm f/5.6	F7.1	1/2000	900	n/a	n/a	30x20
70	Tom's Cove	Nikon D850	Nikkor 50 mm f/1.4	f/13	1/200	64	8	1	60x22
71	Cropper Lane	Nikon D850	Nikkor 85 mm f/1.8	f/16	1/25	64	9	1	72x22
72	Key West Cottages	Nikon D850	Nikkor 50 mm f/1.4	f/13	1/200	64	20	2	71x28
73A	Island sunset	Nikon D500	Nikkor 200–500 mm f/5.6	f/8.0	1/3200	2500	n/a	n/a	24x20
73B	Crabtree Falls	Nikon D850	Nikkor 50 mm f/1.4	f/13	2"	64	28	4	46x45
74	Mill Creek Lake	Nikon D700	Zeiss 28 mm f/2.0	f/10	1/4	100	12	1	62x24
75	Back road off the Blue Ridge	Nikon D700	Nikkor 50 mm f/1.4	f/13	1/25	200	11	1	41x12
76	Village Highway, abandoned building	Nikon D850	Nikkor 50 mm f/1.4	f/14	1/20	64	8	1	50x21
77A	Snowy egrets	Nikon D500	Nikkor 200–500 mm f/5.6	f/6.3	1/5000	200	n/a	n/a	30x10
77B	Barn on Kites Corner	Nikon D850	Nikkor 50 mm f/1.4	f/13	1/80	64	7	1	42x22
78	Humpback Bridge	Nikon D850	Nikkor 85 mm f/1.8	f/11	1/20	64	18	2	70x28
79	Jenkin's Orchard Farmstand	Nikon D750	Nikkor 85 mm f/1.8	f/11	1/100	100	9	1	49x16
80	Fall Road, Shenandoah National Park	Nikon D700	Zeiss 28 mm f/2.0	f/10	1/30	200	9	1	52x18
81	Old apple orchard	Nikon D700	Nikkor 50 mm f/1.4	f/10	1/30	200	11	1	63x25
82A	Ravens Roost Overlook	Nikon D850	Nikkor 50 mm f/1.4	f/13	1/100	64	12	2	60x37
82B	Black bear	Nikon D300	Nikkor 70–200 mm f/2.8	f/8	1/1000	6400	n/a	n/a	20x24
83	Road to Sherando Lake	Nikon D700	Nikkor 50 mm f/1.4	f/11	1/5	200	11	1	52x20
84	Cabins and dogwoods	Nikon D850	Nikkor 85 mm f/1.8	f/10	1/125	64	7	1	48x19

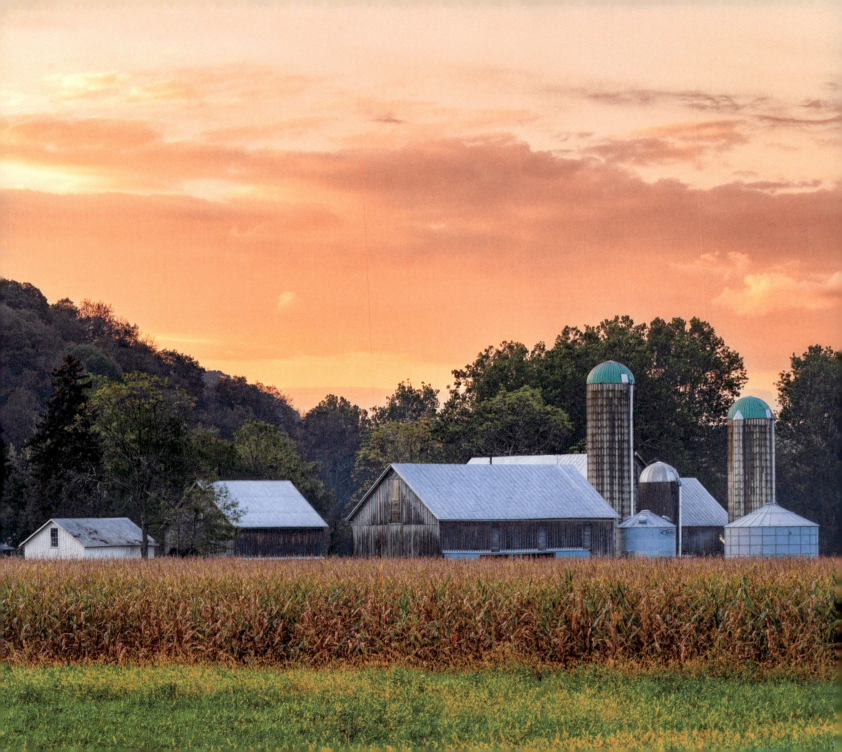